W9-BUR-409

IMAGES
of America

MICHIGAN MEMORIAL PARK

Gail D. Hershenzon

ARCADIA
PUBLISHING

Copyright © 2007 by Gail D. Hershenzon
ISBN 978-0-7385-5159-3

Published by Arcadia Publishing
Charleston SC, Chicago IL, Portsmouth NH, San Francisco CA

Printed in the United States of America

Library of Congress Catalog Card Number: 2007931946

For all general information contact Arcadia Publishing at:
Telephone 843-853-2070
Fax 843-853-0044
E-mail sales@arcadiapublishing.com
For customer service and orders:
Toll-Free 1-888-313-2665

Visit us on the Internet at www.arcadiapublishing.com

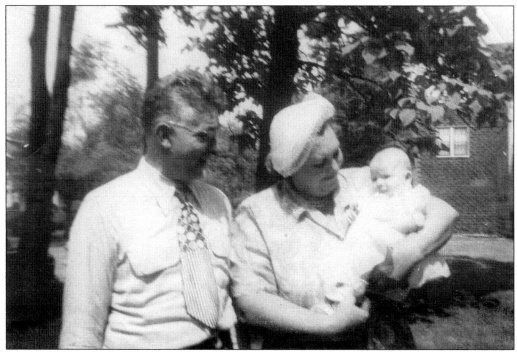

This book is dedicated in loving memory to the author's godparents, James and Marion Green, who were laid to rest at Michigan Memorial Park.

IMAGES
of America

MICHIGAN
MEMORIAL PARK

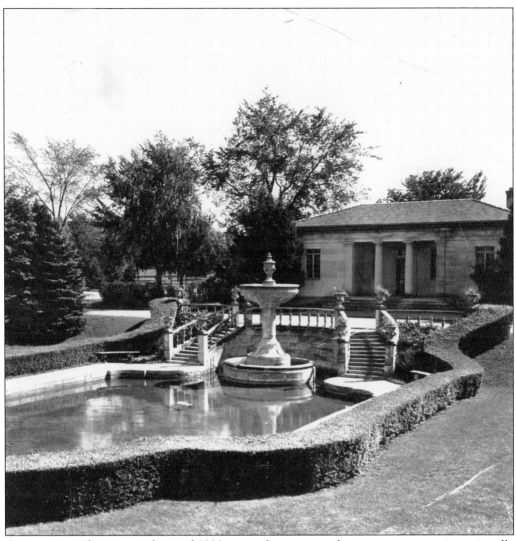

A movement began in the mid-1800s transforming rural cemeteries into intentionally landscaped burial grounds, giving them a garden or a park presence. It started with the Pere-Lachaise Cemetery in Paris, Mount Auburn Cemetery in Cambridge, Massachusetts, and Spring Grove Cemetery in Cincinnati. Cemeteries across the United States would readily adopt this revolutionary model, including Michigan Memorial Park. (Courtesy of Michigan Memorial Park.)

On the cover: This photograph of Michigan Memorial Park, taken in 1935, shows the cemetery in its infancy. Most grave markers are level with the ground following the convictions of 19th century cemetery designer Adolph Strauch (1822–1883) who thought that many cemeteries looked like "a marble yard where monuments are for sale." Well-calculated landscape planning that enhanced the natural and simplistic setting of this former farmland would be consistent throughout the development of Michigan Memorial Park. (Courtesy of Michigan Memorial Park.)

CONTENTS

ACKNOWLEDGMENTS

My sincere thanks goes to John and Mary Fenech who first conceived of the idea that a book should be written about Michigan Memorial Park and had enough faith in me to suggest I be the one to do it.

What a pleasure it has been to meet and work with the owners, family, and employees of the cemetery. I am extremely thankful especially to Kelly Dwyer, Barbara Heston, Patricia Horn, Merry Palicz, Dot Trayes, and Heidi Umin, who trusted me with their valuable documents and told me their personal anecdotes in order for the story of Michigan Memorial Park to be shared. To David Diehl, Herb Evans, Joe Fugedi, Linda Gayer, Jeff Gregory, Sharon Heady, Randy Hersey, Vanessa Ingram, Lois Keenan, Lou Knoff, Maryanna LaVigne, Patti Leaman, Rich Maldonado, Charles Marschner, Sherry Nava, Mike Novak, Tim Novak, Pat O'Neal, Jerry Page, Brenda Patterson, Sergio Perez, Tony Pietrangelo, Larry Piiparinen, Otto Quednau, Gail Redd, Dan Rice, Debbie Rice, Denise Ruoss, Jonie Slowik, Cindy Stevens, Donnie Sutherland, Gerri Sutherland, Karen Taskey, Richard Thompson, David Tomey, Richard Umin, Donna Van De Car, and Phil Wawrzyniec, my heartfelt thanks for making me feel right at home and helping me find my way around the cemetery archives and locate grave sites.

To Amy Barritt, Karen Jania, Ashley Koebel, Beth Kowaleski, Marilyn McNitt, Malgosia Myc, Nancy Mirshah, Kris Rzepczynski, and Mary Wallace, my thanks to these very dedicated librarians and archivists who always offer to do more than what is expected. To Gregory Bishop, Daniel Dwyer, the Koselkas, Gary Powers, Pamela Rodriguez, Garie Thomas-Bass, and Robert Ziegenbein, thank you for your assistance and suggestions. To the Brasch, Kolotila, Palkoski, Rechlin, and Wolf families, you always have words of encouragement, and I am so appreciative that we are family.

And to those who so graciously told me personal stories and shared photographs of their loved ones to be included in this book, know that my gratitude overflows. You have given the readers of this book insight into the lives of people unknown to most but who made our world a little more interesting.

Unless otherwise noted, all images appear courtesy of the author's collection.

INTRODUCTION

On October 18, 1926, Detroit neighbors were debating who they thought would win Michigan's governor race on November 2, Democrat William A. Comstock or Republican Fred W. Green. Families were making plans to attend the Garrick Theatre on October 24 to see what would unknowingly be Harry Houdini's last performance. Husbands and wives were debating if they could afford the $19.75 that the Detroit City Gas Company was charging to install a new water heater. Couples were contemplating which of the $1.25 entrees they should order, the breaded fried lamb chops accompanied by California asparagus or the Yankee pot roast served with macaroni au gratin, prepared by chef Frank Tamm at the Oriole Terrace. Radios were tuned to station WGHP for the evening broadcast of the Frederick Stearns and Company sponsored program of the Astringosoloists who would sing such melodies as "Sweet Genevieve" and "Can't You Hear Me Callin' Caroline." And sadly, parents were praying that their children would be spared the latest round of diphtheria that claimed the lives of 15 little ones in the past week in addition to infecting 125 new potential victims.

At 7:30 that same evening, on the 15th floor of the Washington Boulevard Building, Judge William Martin Heston, a former two-time University of Michigan All-American football hero, summoned Buhl Burton, Leonard K. Rumsey, Harry Vivian, Frank A. Henry, Richard E. Baus, H. F. Sheldon, Edward B. Mackie, W. J. Learmonth, Chalkey Slack, James E. Spencer, Charles L. Bockus, R. W. O'Keefe, M. L. McKinnon, Joseph Meadon, Donald Spears, Mrs. C. E. McCormick, John L. Austin, H. L. Larsen, Kenneth Watkins, R. E. Paris, S. P. Ford, E. T. Doddridge, Frank Sibley, Cay A. Newhouse, Rosa L. Copinsky, Harry E. Simons, W. R. McDonald, John L. Clugston, Ritter Newell, and Jesse W. Sutton together to become stockholders in a newly formed company, Michigan Memorial Park, Inc. One week later, they met again, electing William Heston the president, James Spencer the first vice president, Joseph Meadon the second vice president, Leonard Rumsey the treasurer, and Frank Sibley the secretary. Following the Public Acts of 1869, Act No. 12 gave them the authority to "authorize and encourage the formation of corporations to establish rural cemeteries, and provide for the care and maintenance thereof." They established their Articles of Association and pooled their resources of $100,000 with each investor owning between 5 and 50 shares. With a value of $100 per share, Heston invested the most and held 250 shares. They handpicked Paul Heinze to be the engineer. Talmage Hughes was appointed the architect who would propose the layout of the cemetery and design the buildings. Clearing about 178 acres, they carved gravel-laden roads, planted trees, and platted the first burial sections. Almost two years from their first meeting, they were ready to open the iron gates and let the Huron Township residents welcome this new addition to their community.

The property had been owned by William and Fannie Smith since 1911 and in 1925, Frank and Henriette Farnham were given a land contract for it. In 1926, Heston acquired the property located in this roughly 35–square mile section of agricultural landscape for $217,500. With a $100,000 down payment, the balance was to be paid in $10,000 installments over five years, and then interest would be added with payment on the remaining balance being required every six months. It was understood that the agreement was made by Heston for the benefit of Michigan Memorial Park, Inc. By October 1927, with the sales of cemetery plots totaling over $514,000, it had become a fully operative cemetery. In January 1928, preparation was being made to have at least 30 acres of land readied to accept burials by June 1. Costing the cemetery $143,000, the Dayton Company installed a sprinkling system, the first of its kind, which would bring water from the Huron River to the cemetery. The erection of the granite and iron entrance would require $15,000. It was decided that the Walbridge-Aldinger Company would be contracted to construct the administration building, and the Weigel-Brown Company, using the plans of architects Lovell and Lovell, would install an iron fence along Huron River Drive and Willow Road. Furniture for the administration building would come to $3,807.60 with an additional $476.95 needed for lighting fixtures. Three new Fordson tractors, priced at $650 each, were purchased to grade the property. They settled on Ed Sanders of Monroe, to use the plans of a Mr. West of Chicago, who was a landscape architect, for the planting of trees and shrubs at the cost of $11,124.10. Paul Heinz would continue to see that the property was improved, and Willie Smith of Detroit provided the needed grass seed. Walbridge-Aldinger Company was called upon again to construct roads for a little over $20,000. And a few months later, on October 16, 1928, 11-year-old Florence Lorain became the first person interred in the Sylvan Gardens section at Michigan Memorial Park.

Little could anyone speculate that this cemetery would become one of the township's most notable spots, not just for lying loved ones to rest, but for the cemetery's contribution to the community. From the start, the cemetery has provided employment for many of the township's residents, even during one of the bleakest times in U.S. history, when the Great Depression hit one year after the first burial. Since the beginning, the owners have participated in civic activities and have opened undeveloped parts of their grounds to non-profit organizations for use. From those whose lives earned their names to be placed in the daily headlines to those whose only newspaper appearance was their obituary, Michigan Memorial Park has welcomed anyone wishing to make Michigan's largest non-denominational cemetery their final resting place.

One

From Footballs
to Funerals

Motivation and perseverance took two-time University of Michigan All-American football hero William Martin Heston from herding cattle, to scoring touchdowns, to prosecuting the lawless, and, finally, to helping those in mourning. The son of a tenant farmer, Heston used his skills and values learned while growing up to become an outstanding family man, businessman, and citizen. From his unpublished autobiography, Heston wrote that he was born September 9, 1878, on the outskirts of Galesburg, Illinois, one of five siblings. His early years moved him to Iowa, Kansas, Oregon, California, and Michigan, teaching him how to survive even in the worst of times. Youth never stood in the way of him taking on responsibilities, or learning to do without, to make a better life for himself and his family. He helped his father cut down fir trees and sell them for stove wood. Much of his clothing was remade from clothing belonging to his father and brother. Christmas meant an orange and some hard candy. To earn money for college, he worked as a porter in a second-class hotel, sweeping hallways and cleaning brass cuspidors. Heston's high school never had any sports teams, but foot races were very popular. It was running those races that Heston discovered his knack for speed that others would notice later on, including Jesse Woods, the football coach at San Jose State Normal, where Heston's football history began. Eventually he met one of the most successful coaches in football history, Fielding M. Yost, who helped turn Heston's life in a direction Heston probably never expected. With Yost's interest and encouragement, young Heston became one of the University of Michigan's star football players and would later be inducted into the College Football Hall of Fame and the Iowa Sports Hall of Fame. While at the university, studying law accompanied his football achievements, and Heston went on to become one of Detroit's well-known attorneys and judges. Investing in real estate, Heston bought land and, in 1926, started turning one of those parcels into one of Michigan's largest cemeteries, Michigan Memorial Park.

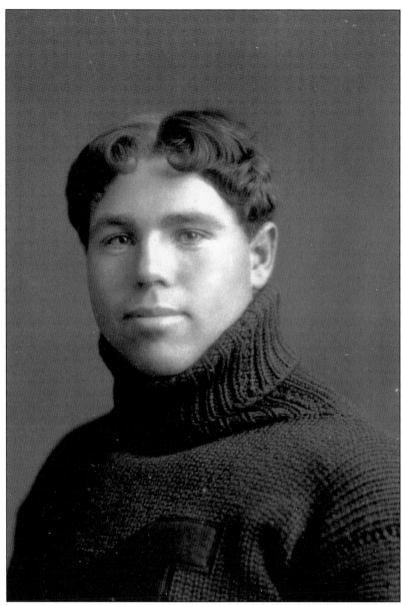

William Martin Heston was a two-time All-American football hero for the years 1903 and 1904. This photograph shows Heston when he was the University of Michigan's football team's captain for the year 1904. Heston's early years required him to herd cattle on his uncle's ranch. From December through March, he was allowed to attend school, even though it meant walking over three miles of prairie and sometimes through snowstorms. His speed, which netted him a place in football, could be traced to his youth when he excelled in recess games of Dare Base, Wolf, and Pullaway. As a boy living in poverty, Heston would recall the days of living in a home constructed out of pine boards. The inside walls of the downstairs were plastered but the upstairs rooms were not. Heston would waken on winter mornings only to find he was covered with snow that had drifted in between the pine boards. Through these tough times, he would lose two sisters, Rose and Elizabeth, due to flu and tuberculosis. (Courtesy of Bentley Historical Library, University of Michigan.)

This 1903 photograph shows George "Pa" Gregory (left) with Heston. Gregory, who played center in 1901, 1902, and 1903 for the University of Michigan, spoke with a drawl that Heston would jokingly mimic. In turn, Gregory began to call Heston "Willie." It soon caught on and Heston was referred to as Willie rather than William most of his life. (Courtesy of Bentley Historical Library, University of Michigan.)

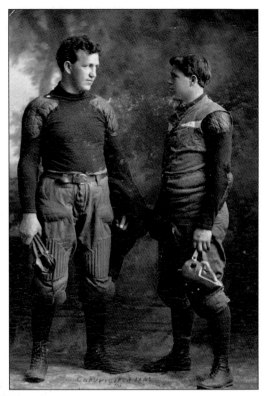

Heston was part of the "point-a-minute" team and played in the first Rose Bowl game held January 1, 1902, with the University of Michigan beating Stanford University 49-0. In this photograph taken at the event, Fielding Yost is seen in the first row with his right arm extended. Heston is in the second row, third from the left. (Courtesy of Michigan Memorial Park.)

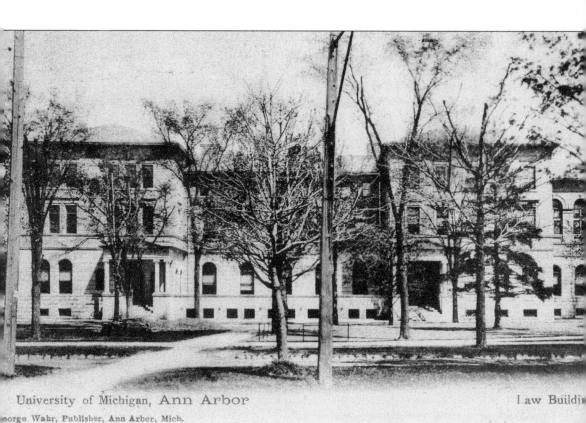

University of Michigan, Ann Arbor Law Buildi

oorge Wahr, Publisher, Ann Arbor, Mich.

This postcard dated 1911 shows the law building on the University of Michigan campus where William Heston attended law school and led the school's football team into several successful seasons. According to Heston's unpublished autobiography, "after Heston graduated from the law department of the university, he devoted his time to general law practice in Detroit, with the exceptions of the fall of 1905 when he coached the Drake University football team, and in the fall of 1906, when he coached football at North Caroline State. In 1911, he was appointed Assistant Prosecutor for Wayne County and served in that capacity until he was elected to the Bench in 1916. He served as Judge of the Recorders Court until January 1923, when he went back to practicing law and was also active in real estate."

When Heston was four years old, his family moved from Illinois to Rippey, Iowa, near Des Moines. Contracting whooping cough and pneumonia, the doctor pronounced that seven-year-old Heston had little hope of survival. Heston recovered only to face death a second time. Learning to swim, he was caught under some driftwood after being carried there by the current. His sister Grace rescued him. (Courtesy of Dot Trayes.)

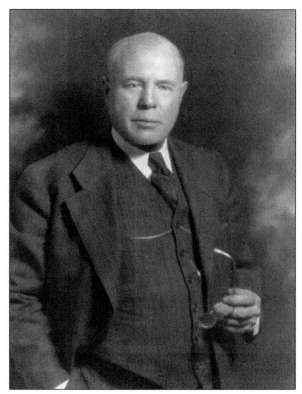

Q
♣

William Heston
halfback, 1901-1904

Two-time All-American scored a record 71 touchdowns in his career

♣
Q

Heston's notoriety landed his caricature on decks of playing cards. Playing for the University of Michigan, the team won four national championships. After graduation from high school in Grants Pass, Oregon, Heston planned on becoming a teacher. He went to San Jose State Normal School where his friend Fred Estes was the football captain. Heston remarked he never saw a football before but Estes wanted him on the team anyway.

ALL AMERICAN

WILLIE HESTON *Halfback*

Stanford's football coach, Fielding Yost, coached on the side for San Jose State Normal School. When Yost became the coach at the University of Michigan, William Heston left California, followed Yost, and became a Wolverine. As part of the University of Michigan's football team, Heston saw the team score a 43-0-1 record.

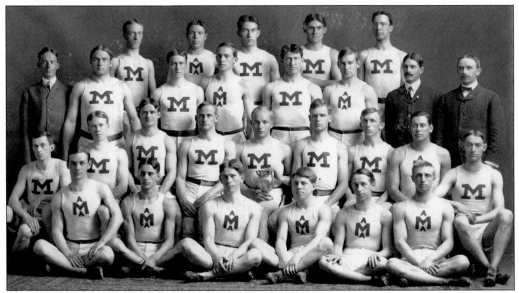

In 1892, 13-year-old Heston left home looking for a job. Hiking, stealing rides in boxcars, and sleeping with hogs to stay warm, Heston found work on a farm. Noted mostly for his football accomplishments, Heston was also on the university's track team seen here in this photograph of the 1903 Western Champions. Heston stands in the fourth row, second from the left. (Courtesy of Bentley Historical Library, University of Michigan, Wilfred B. Shaw Collection.)

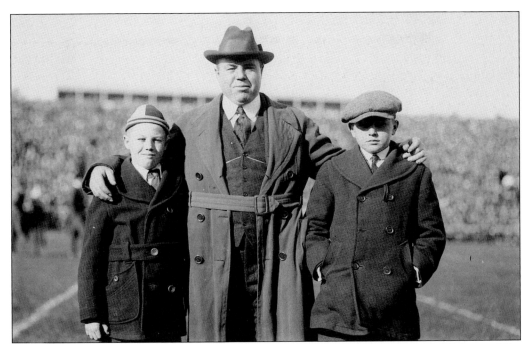

On December 23, 1907, Heston married Lydia Frances Sisson from Monroe, Michigan. The marriage produced two sons and a daughter. Heston poses on the football field at the University of Michigan with his two sons in this photograph taken around 1926. (Courtesy of Walter P. Reuther Library, Wayne State University.)

Heston appears to be having a fireside chat with his sons, who would later join him in the cemetery business. In 1955, William M. Heston Jr., pictured with his arm on the mantel, would become first vice-president, and John P. Heston, standing with hands in his pockets, would serve as secretary and treasurer of Michigan Memorial Park. Eventually John would become president. (Courtesy of Dot Trayes.)

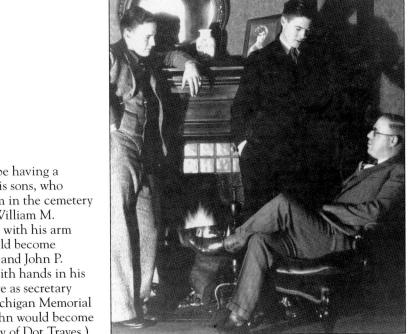

William Heston's notoriety as a football star was only surpassed by his generosity. He worked, early on in his career, with charitable groups such as the Boy Scouts of America, as seen here in this undated photograph. He moved in a wide circle of organizations that depended on contributions from businesses and leaders in the community. A judicious businessman, Heston was kindhearted when it came to helping those in need. Not forgetting his grass roots, Heston offered many scholarships to area students pursuing their college education. (Courtesy of Michigan Memorial Park.)

This photograph of 2454 West Boston Boulevard in Detroit was the home where Heston lived with his family while a practicing attorney and later serving as a judge in Detroit. Affluent Boston Boulevard was once home to many of Detroit's well-heeled families including the Kresges, the Grinnells, the Burtons, the Himelhochs, the Dodges, and the Siegels.

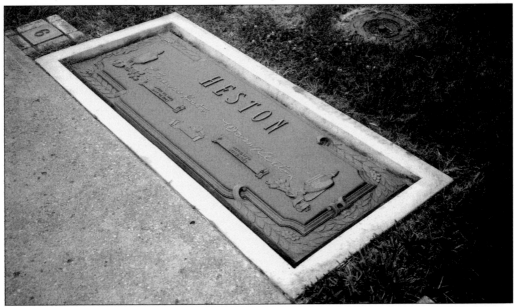

Passing away on September 9, 1963, his 85th birthday, Heston was laid to rest next to his first wife, Lydia, who had died May 26, 1953. Heston's pallbearers were Jack Blott, Harry Newman, Bennie Oosterbaan, Otto Pommerening, Henry (Ernie) Vick, and Francis Wistert, all former University of Michigan All-Americans. The Hestons are buried in the Companion Gardens, block 42.

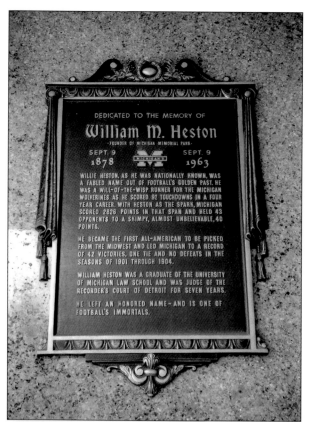

Hanging in the Shrine of Remembrance at the cemetery he founded, this plaque neatly sums up William Heston's major accomplishments as a University of Michigan Wolverine. The superstar of the University of Michigan's point-a-minute teams coached by Fielding Yost, Heston played in only one game that the university did not claim victory.

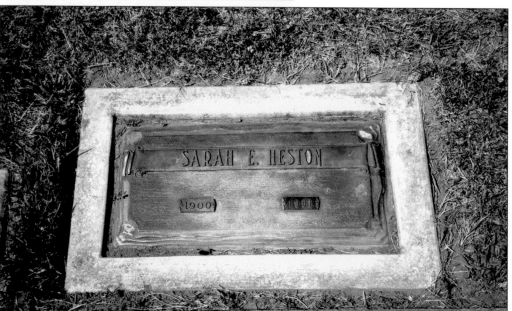

Heston's second wife, the former Sarah Ellen Williams, died October 27, 1991. She was a native of Bay City, Michigan, and had married Heston in 1956. She was interred in the Companion Gardens, block 42, in the Heston family plot.

Two

Not Just Another Cemetery

The Roaring 20s were on the way out, and the "Dirty 30s" would soon begin when Michigan Memorial Park celebrated its opening. The cemetery's stockholders, along with the rest of Huron Township and its next door neighbor, Flat Rock, would soon feel the effects of the stock market crash and the Great Depression, the termination of rum-running and Prohibition, and of organized crime. The nation seemed to be spinning out of control, and the community was greatly concerned who would be able to get the state and the nation back on its feet. Folks in this community had also witnessed the end of the Great War, not knowing that another major war was getting ready to claim the life of some of its residents. Flat Rock was a typical small town of that era closely linked to the cemetery by way of it using the city's name as the cemetery's mailing address. Its churches, funeral home, and florists would soon grapple with increased business by the start of this new burial ground. Although Michigan Memorial Park started out just like any other cemetery, it developed into becoming a leader in its business. Unlike so many cemeteries, it was away from bustling cities, which was an attractive reason to choose this farmstead setting as a place to be laid to rest. They were the first to entertain new ideas on how a cemetery should function, including pre-need selling of burial plots, unheard of at that time. Undeveloped parts of the cemetery were used as garden spots by local gardening clubs. Helicopter rides were being given for prospective clients to choose their burial spot from the air. Scholarships were being handed out to local high school seniors. Michigan Memorial Park's relationship with the townspeople was crucial to William Heston, and the people who had welcomed this new cemetery would be thanked by his philanthropic deeds.

In 1798, Grosse Roche, meaning "large boulder," was the first name given to the area that would eventually be called Flat Rock. With its panoramic and captivating landscape and fertile farmland, this place would attract many future farmers. (Courtesy of Daniel C. and Mary E. Van Wasshenova.)

FLAT ROCK, MICHIGAN

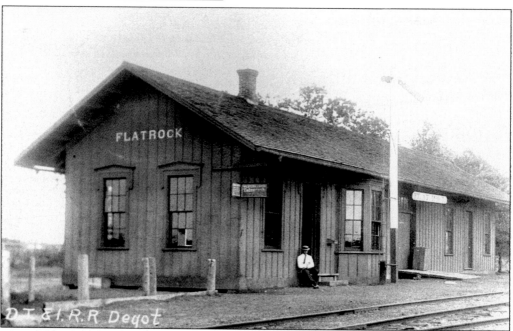

An unidentified gentleman sits in front of the old Flat Rock train depot in this undated photograph. It is gone now, but train depots like this one were a standard structure in many small towns. This train depot was also home to the office of the Western Union Telegraph. (Courtesy of Superior View.)

Flat Rock had been settled by and named for Michael Vreeland. Like so many early settlers of Michigan towns, Vreeland came from New York. Flat Rock would change names a couple more times, including being called Smooth Rock, before officially being named Flat Rock in 1838. (Courtesy of Daniel C. and Mary E. Van Wasshenova.)

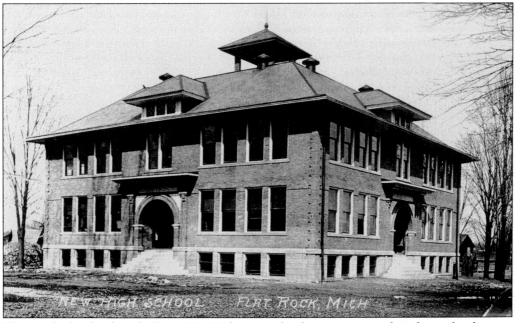

The new high school was built in 1911. Today a weather-beaten sign stands in front of it claiming it as the home of the Flat Rock High School Science Club. No longer used by the school district, it was sold to the city several years ago. (Courtesy of Daniel C. and Mary E. Van Wasshenova.)

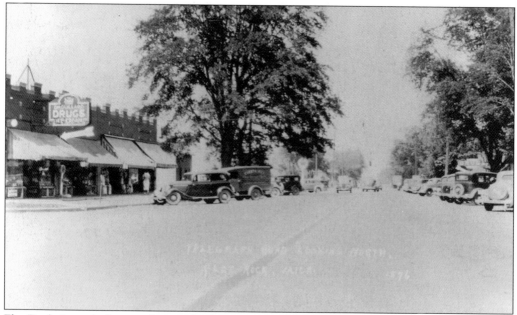

Flat Rock, just a little over three miles from Michigan Memorial Park, was a rural town that had typical businesses lining the main thoroughfare, Telegraph Road. In this undated photograph of Telegraph Road, looking north, the Drouillard family, a well-known name in the community, ran the drug store on the left. (Courtesy of Superior View.)

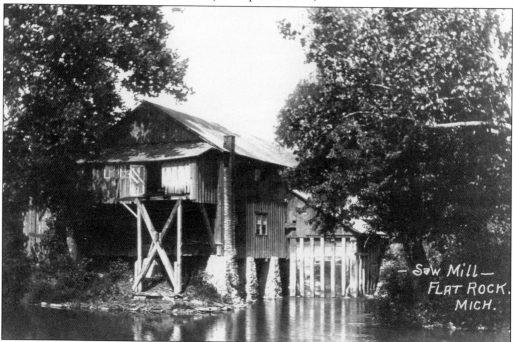

Located near the tranquil Huron River, the sawmill in Flat Rock, pictured here in this undated photograph, would become one of the town's busiest places providing lumber for many of the homes, farms, and businesses springing up in the immediate area and nearby towns. (Courtesy of Superior View.)

These two undated photographs of Huron Street, one of the main streets in Flat Rock, show the same building at different times. In the photograph above, the street has not yet been paved as in the photograph below. In front of the shops in the above photograph, horses could be hitched in order to go about one's business. In the photograph below, automobiles are now the mode of transportation, and a sweet shop sign graces the front of the building. Paved roads and better sidewalks would help businesses prosper yet help Flat Rock maintain its quaint and quiet charm. (Courtesy of Superior View.)

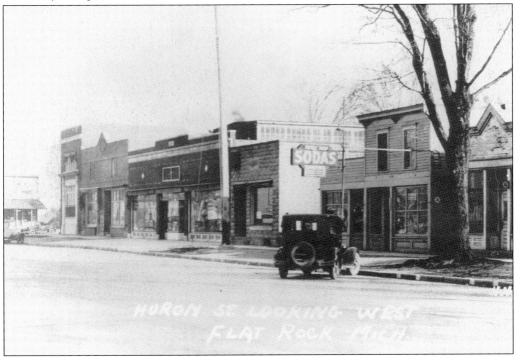

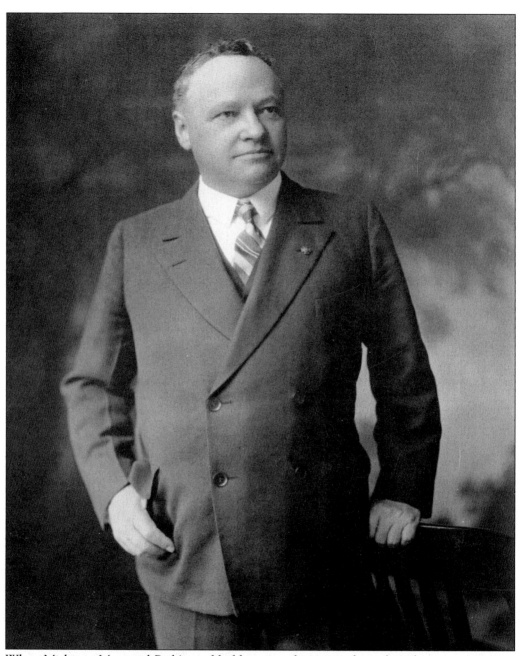

When Michigan Memorial Park's stockholders were discussing their plans for a new cemetery in 1926, Michigan's residents were discussing who they should vote for, Fred Warren Green or William Alfred Comstock, to become the state's next governor. Green, a Republican, would win the race and serve the state in that position from January 1, 1927, to January 1, 1931. He had attended Michigan State Normal School, and, while a student at the University of Michigan, he graduated with a degree in law in 1898. He had also been Ionia's mayor from 1913 to 1916, before seeking the governor's position. As the 31st governor, he would be the one that would have to help his constituency through the dark days of the Great Depression. He would die a little over five years after leaving office. (Courtesy of Bentley Historical Library, University of Michigan.)

Democrat Comstock would lose the November 2, 1926, governor's election to Green and would lose again to him in 1928. The University of Michigan graduate would run against Wilber Brucker in 1930 and would lose that race, too. In 1932, he defeated Wilber Brucker and served from January 1, 1933, to January 1, 1935, as Michigan's 33rd governor. During his reign, the residents of the Flat Rock area, as well as the rest of Michigan's population, would see the state authorize its first sales tax law. After he left office, Comstock was part of the Michigan Civil Service Commission and served on the Detroit City Council up until his death in 1949. (Courtesy of Bentley Historical Library, University of Michigan.)

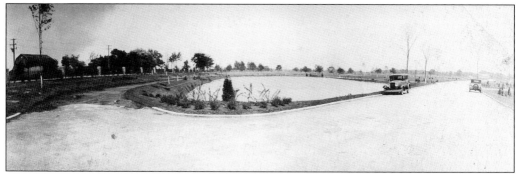

These early photographs show Sylvan Lake, which is positioned to the left upon entering the cemetery gates. In preparation for its opening in 1928, 30 acres of land were thought to be sufficient to get the cemetery ready to accept burials. The graded dirt roads would eventually be paved, and more landscaping would be done to give the cemetery a better park-like appearance, hence the name Michigan Memorial Park. Wanting loved ones to think in more pleasant terms of death and wanting to focus on the idea that cemeteries were for the living, the owners created an atmosphere that would be appealing to visit through its careful layout of flowering trees and shrubs. An abundance of sculptures and memorials would be designed and placed throughout the grounds to soften the devastation brought by a loved one's death. (Courtesy of Michigan Memorial Park.)

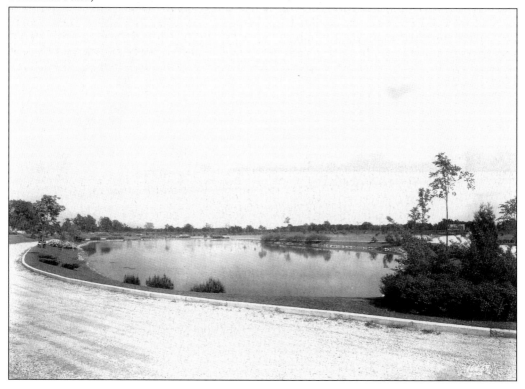

Looking toward the entrance gates of Michigan Memorial Park, the administration office can be seen on the left. On the far right, a farmhouse sits across the road from the cemetery. Beauty was one of the main concerns when the cemetery was first developed so horticulture weighed heavily in its design to make the cemetery picturesque but not pretentious. (Courtesy of Michigan Memorial Park.)

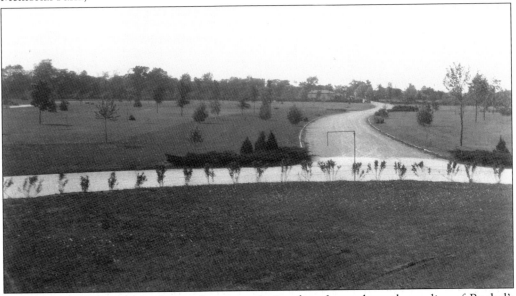

This view of the cemetery, facing the entrance, is taken from where the replica of Rachel's Tomb used to be and where the Shrine of Remembrance stands today. The dirt road leading to the entrance would later be paved and lined with flags of every state of the union. During the holidays, such as the Fourth of July, all the flags are replaced with the Stars and Stripes. (Courtesy of Michigan Memorial Park.)

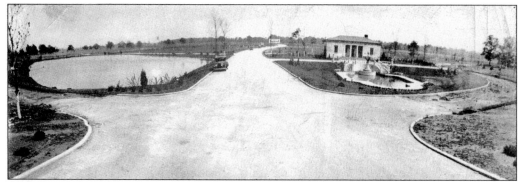

After the Wyandott tribe settled in this area, many New Yorkers came to this part of the state to begin farming and setting up their industries. The land where the cemetery is today was no exception. The land was exceptional for farming with its natural drainage and fertile soil. (Courtesy of Michigan Memorial Park.)

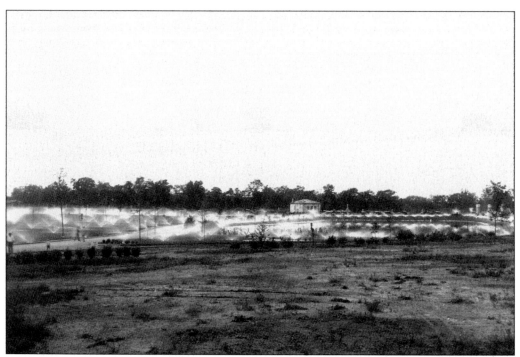

When the underground sprinkling system was installed in 1928, Michigan Memorial Park boasted having the largest one of its kind, giving the cemetery the moniker, "Land of a Thousand Rainbows." It covered every inch of the grounds, giving the cemetery a continuous lush green lawn. (Courtesy of Michigan Memorial Park.)

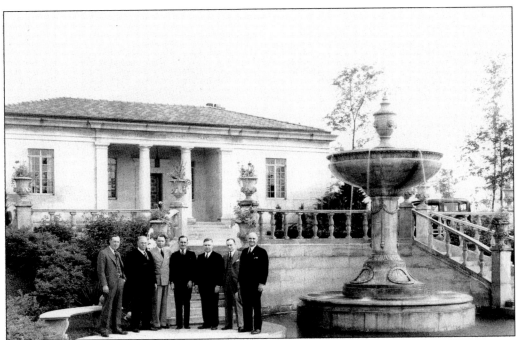

In this undated photograph, William Heston (second from left) stands in front of the first cemetery administration building with other unidentified gentlemen, possibly Michigan Memorial Park's board of directors. Heston would remain president of the corporation until relinquishing the position to his sons when his health began to decline. (Courtesy of Michigan Memorial Park.)

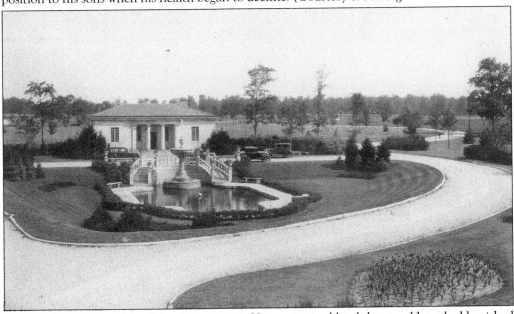

When the land was selected for cemetery use, Heston wanted land that would not be blemished by housing developments or industry expansion. Not wanting smoke, dirt, and noise that major cities offered, he chose a spot that would foster placidness and transcend all other cemeteries. Even today, farms remain and a few houses border the cemetery property. (Courtesy of Michigan Memorial Park.)

MICHIGAN MEMORIAL PARK

1510 WASHINGTON BLVD. BLDG.
D E T R O I T

To our customers: May 24th, 1930

THE PUBLIC DEDICATION

of

MICHIGAN MEMORIAL PARK

will be held

SUNDAY JUNE 8, 1930

at 2:30 P. M.

instead of Decoration Day as formerly planned.

During the preparations for our dedication we found that President Hoover is to talk over the radio on a national hook up, also at least two large celebrations are planned for the same hour in and near Detroit on Decoration Day. We therefore believe it desirable to change the date as above mentioned.

The improvement work is steadily progressing. The underground sprinkling system is completed in several blocks and will be turned on that afternoon. A very fine program is planned for the occasion.

We hope every owner will find it possible to be present for this program and assure you it will be worthy of your time. Awaiting to see you at that time, we remain

Sincerely yours,

MICHIGAN MEMORIAL PARK, INC.

WMH:RJ President.

An unidentified man stands in front of the entrance gates of the cemetery in the photograph at the top of the letterhead announcing the formal dedication of Michigan Memorial Park that would be taking place on Sunday, June 8, 1930, at 2:30 in the afternoon. The announcement mentions that the celebration had been intended to be on Decoration Day, which is now called Memorial Day. Even though the first burial had occurred over a year and a half before this dedication would take place, many more magisterial improvements had been made to the cemetery since that time, and more were on the drawing board. It was important to let the public see this professionally designed park-like setting and the progress the cemetery was making in order to make it appealing for future buyers of burial plots. (Courtesy of Michigan Memorial Park.)

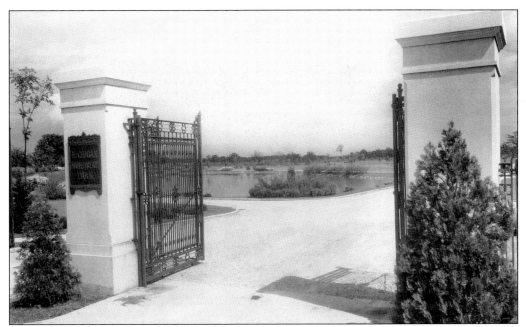

The rural area around the cemetery is about the same today as it was in this early photograph of Michigan Memorial Park. Farms exist that have been in the same families for generations, just as the cemetery is now run by the fourth generation. Vegetable stands at the end of long driveways that once sold corn and tomatoes do the same kind of business today. (Courtesy of Michigan Memorial Park.)

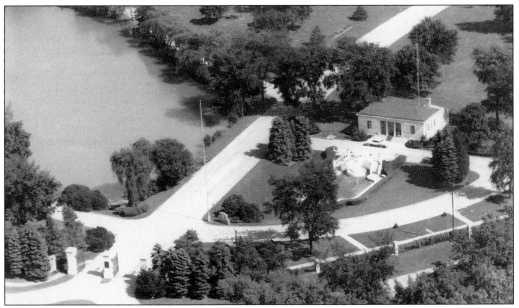

An aerial view of the cemetery shows the wholesome growth of trees and additional curative landscaping added since its early beginnings. Fencing would gradually be added to completely enclose the grounds. The administration building shows the antenna that once was used for Sunday broadcasts over local radio stations. After many years, the reflecting pool and fountain had deteriorated beyond repair and were removed. (Courtesy of Michigan Memorial Park.)

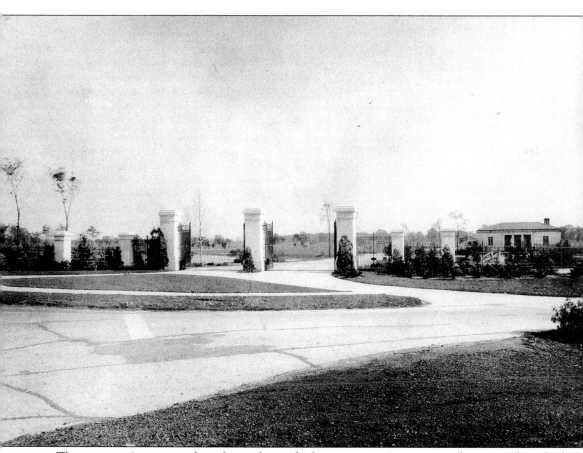

The cemetery's entrance has changed very little over time. At one time however, there had been plans to have visitors greeted by an extravagant assembly of buildings. Stretching 400 feet across the gated entrance was to be a 72-foot-tall tower flanked by a cathedral-looking chapel, administration office, and a mortuary. It would also have one of the few crematories in the area. These bold and captivating structures would be adorned with statues, stained glass windows, and intrinsic carvings. Tiles of every kind would provide color and beauty. Cloisters or pergolas would connect the buildings. Behind the tower was to be a fountain that would spray water highlighted by colored lights 30 feet into the air. The entire conglomeration would be lighted at night giving a palatial effect. (Courtesy of Michigan Memorial Park.)

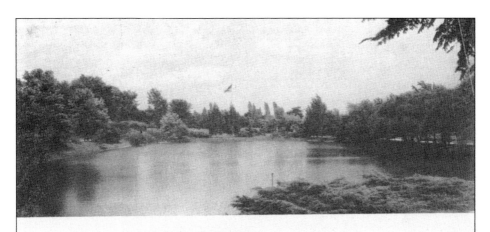

"MAN PROPOSES—PROVIDENCE DISPOSES"

It would be the cause of deep regret to us should this letter inadvertently enter the home of serious illness – but while you are in good health, it is proper, in fact, is only fair to those whom you love and whom depend on you, to give this matter careful attention while the mind is free from the distraction and grief so natural during the inevitable time of sorrow.

We find on that sad day when the need for a burial plot is immediate that the family is in no mental condition to give it careful thought. An unwise and hasty selection is often made, but now you will be able to give undisturbed attention to a selection which will be pleasing and consoling; the last resting place of those who are dearer to us than life itself.

We have inaugurated a Before-Need-Plan of sale and have selected many beautiful sections of Michigan Memorial Park for this purpose. In these sections, while development work is still going on, we are offering burial lots at reduced prices and on terms of monthly payments to suit your convenience.

The skill of the landscape engineer and gardener have been lavishly spent to make Michigan Memorial Park a place of quiet, restful beauty. Truly it may be said – Michigan Memorial Park will always remain a "quiet rural retreat sacred to the dead forever."

Details of our Before-Need-Plan-Of-Purchase will be furnished at once if you will sign and mail the enclosed, stamped postal card.

Michigan Memorial Park

William Heston

President.

P. S.—If you are of Catholic faith, inquire of us about MT. CARMEL DIVISION of MICHIGAN MEMORIAL PARK.

In the 1950s, a son of William Heston, John Penrod Heston, initiated the idea of pre-need purchasing, as opposed to at-need purchasing, of burial plots. It was not unusual to receive a telephone call or a knock at the door inquiring if the homeowner were interested in making their funeral plans so that the remaining loved ones would be free of making decisions during an emotional time. This brochure was one of the first ones that would be used to advertise the availability of property at the cemetery. Inside the pamphlet, photographs showing the beauty of the cemetery accompanied the host of advantages purchasing cemetery property at Michigan Memorial Park would give. Becoming the mainspring for selling cemetery property, the selling of pre-need burial space was a success and is used by many cemeteries today. (Courtesy of Michigan Memorial Park.)

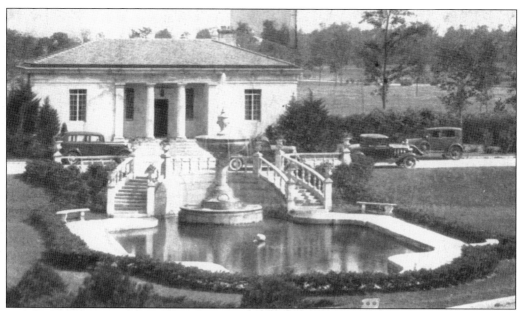

Used for advertising or mementos, these postcards with the photographs taken years apart show the maturity of the greenery along with the change in transportation, yet the administration building and reflection pool with its fountain stayed the same. It would be years later that John Heston, as president of the cemetery, would replace the pool and fountain with a military memorial. Even though space was no longer needed for their weekly broadcasts, the administration building would have an addition built on to it providing more space for counselors and staff. (Courtesy of Michigan Memorial Park.)

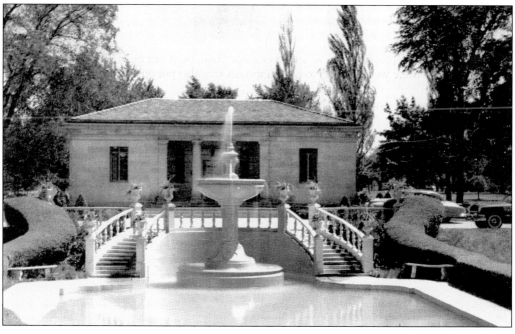

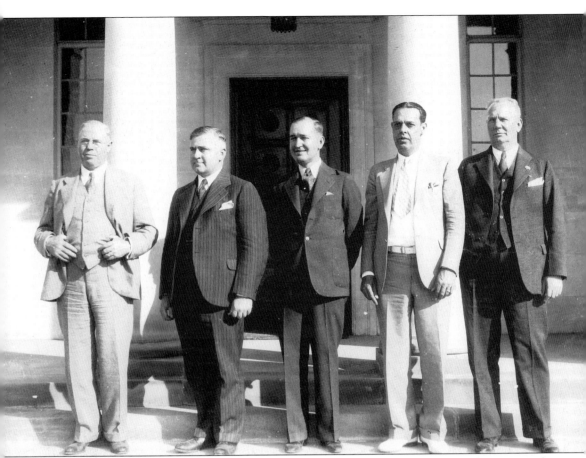

Dapper William Heston, with thumbs in his vest pockets, advertised the advantages of purchasing cemetery property. It was an investment that could not be seized for debt and was not taxable, and there were no dues to pay. Emphasis was also put on the limited availability of burial space in the Detroit area. From 1910 to 1920, Heston stated that the population increase in Detroit was much higher than other major cities yet Detroit had the least amount of burial space. According to his research at that time, Baltimore had a population of 750,000 and had 58 burial grounds. Detroit however, had a population of 1.5 million and had only 14 burial grounds. This was emphasized to show that an investment in cemetery property could always be sold if needed due to the limited supply and the increasing demand for burial space. (Courtesy of Michigan Memorial Park.)

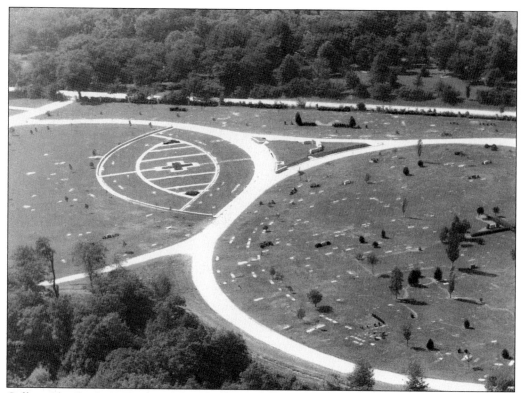

Calling Flat Rock 314F12 would connect the caller to the cemetery located on Huron River Drive at Willow Road. The rural site was chosen because city growth saw the ruin of many cemeteries due to abandonment or the need to use the land for homes and businesses. The football-shaped section to the left in this photograph would later be modified removing the road to the right of it, eliminating the triangular section. (Courtesy of Michigan Memorial Park.)

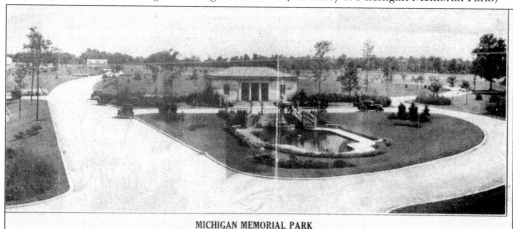

MICHIGAN MEMORIAL PARK
MICHIGAN'S FINEST GARDEN PLAN BURIAL ESTATE
On Huron River Drive, 3½ Miles West of Flat Rock, Michigan Photographed May 30, 1932

Using this advertisement, with the photograph taken May 30, 1932, it was hoped that the beauty of the area would attract more people away from purchasing burial plots in the cities nearby. Emphasis was put on the cemetery's location of being surrounded by woods and water. (Courtesy of Michigan Memorial Park.)

36

A roadside sign touts the appealing aspects of Michigan Memorial Park in this undated photograph. The sign no longer exists but since the cemetery had become so well-known, passersby no longer needed a sign indicating that they were approaching the cemetery. (Courtesy of Michigan Memorial Park.)

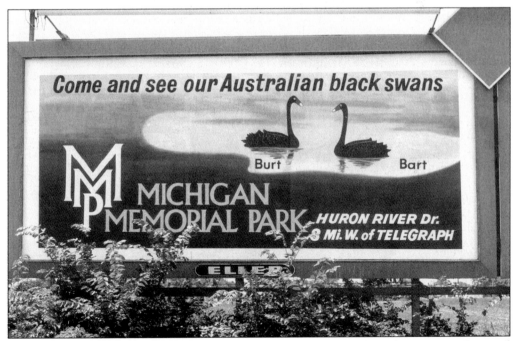

Even though there are swans that still make their home in the ponds of the cemetery, Burt and Bart, the Australian black swans, left long ago, and the sign was removed. Visitors sometimes made special trips to the cemetery just to spend a placatory afternoon admiring the swans. (Courtesy of Michigan Memorial Park.)

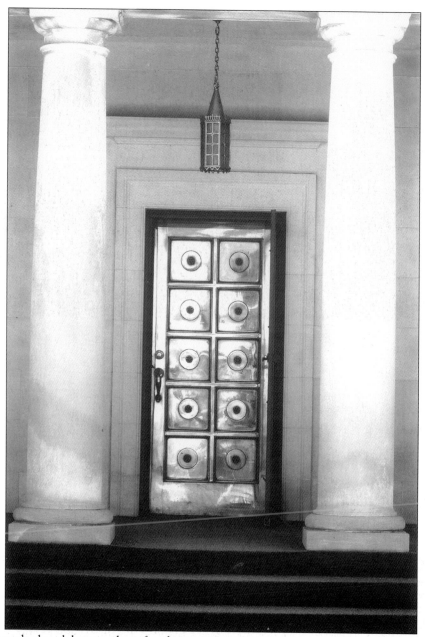

Even though the elaborate plans for the cemetery entrance never materialized, some of the accessories incorporated in the administration building design gave the feel of elegance, starting with the enormous brass door that greeted all who walked through the main entrance. Bordered by two massive pillars and soft lighting, the door continues to usher in all who visit Michigan Memorial Park. During the Great Depression, many of the stockholders who had lost most everything in the stock market crash wanted to cash in their investment they had made with the cemetery. William Heston obliged and was able to honor their requests. It may have been that the cost of running a cemetery was costlier than they thought or because of the economic condition at that time, it was better to curb their spending on extravagant buildings, and they put the money to better use. (Courtesy of Michigan Memorial Park, photograph by John Heston.)

Most of the hedges seen in this undated photograph were removed. Although it was pleasing to the eye and well-designed, the area was stripped of its myriad of plantings to allow for more burial space. The Heston family plot is located near this entrance. (Courtesy of Michigan Memorial Park.)

The back of the first administration building would receive an addition that would duplicate the look of the original building. This photograph shows the back view of the facility after John Heston had it enlarged. (Courtesy of Michigan Memorial Park, photograph by John Heston).

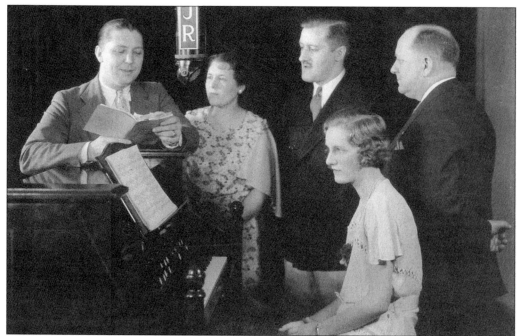

These unidentified men and women were the first group to participate in the Sunday morning broadcasts that were first aired from the cemetery administration building over the radio stations WJR and WXYZ. A Vox Organo would later replace the pump organ. William Heston decided that if the Vox Organo were to be purchased, an addition to the administration building was needed to house the organ and provide a place for broadcasting with another structure to house the speakers. In 1934, Heston presented the board of directors with a picture of a replica of Rachel's Tomb. If no addition to the administration would be built, he suggested that a replica of Rachel's Tomb be erected. (Courtesy of Michigan Memorial Park.)

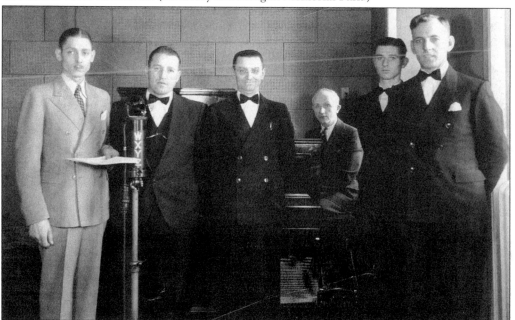

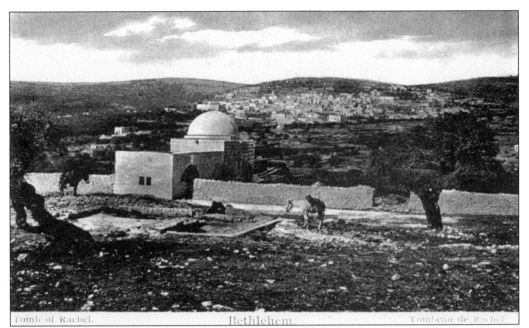

Tomb of Rachel. Bethlehem. Tombeau de Rachel

This early postcard of Rachel's Tomb shows the domed structure that Heston wanted duplicated when he was thinking where to hide the organ speakers. Rachel's Tomb is where the Biblical Rachel, wife of Jacob, is thought to have been buried, just outside the city of Jerusalem on the way to Bethlehem. Gerhardy Building Company was the contractor for this project at the cost of $1,241.50.

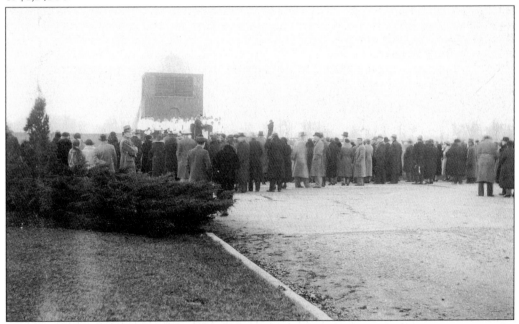

This may be the dedication ceremony of the replica of Rachel's Tomb that was built. In 1956, $500 would be used to make some repairs on the organ, and it was agreed by the board to purchase a service policy for the organ at the cost of $100 per year. (Courtesy of Michigan Memorial Park.)

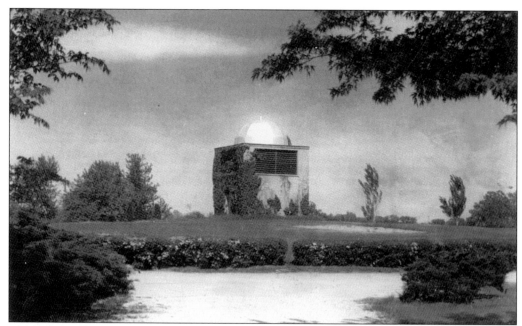

The back of this postcard reads, "Our replica of Rachel's Tomb houses the speakers and amplifiers of our public address system and pipe organ. This facility is used for all funerals and for our monthly memorial programs." This building was later removed and was replaced by the Shrine of Remembrance. (Courtesy of Michigan Memorial Park.)

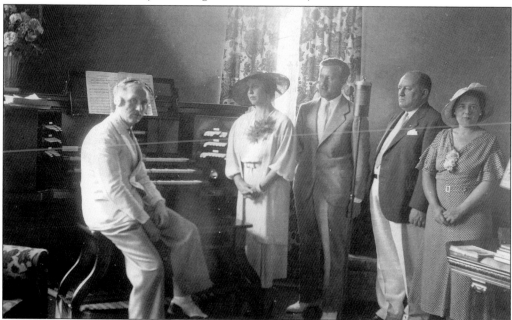

Don Miller, sitting at the console, is the only one identified in this photograph taken August 5, 1934. The Vox Organo was built by Musical Research Products in Philadelphia. Costing the cemetery $15,000 in 1934, it was used for their weekly broadcasts over WJR and WXYZ. The organ would eventually be donated to the First Baptist Church of Lincoln Park. (Courtesy of Michigan Memorial Park.)

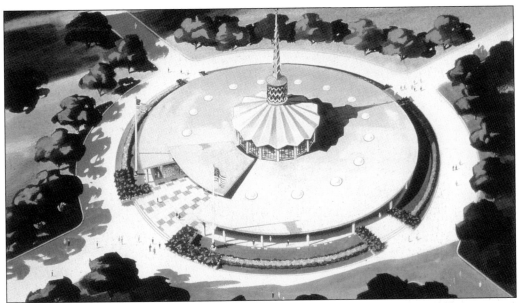

The November 12, 1957, minutes of the cemetery's board of directors reads, "Mr. Emmons was requested to draw up a motion, for the next meeting, pertaining to the commencement date of garden crypt construction on block 19." This sketch shows an architect's vision of what the Shrine of Remembrance might look like. (Courtesy of Michigan Memorial Park.)

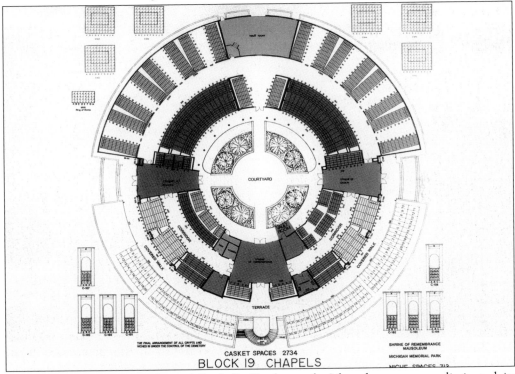

Block 19 is where the replica of Rachel's Tomb stood. After the cemetery eliminated its Sunday broadcasts, the structure was dismantled. This sketch shows the layout of the Shrine of Remembrance that would take its place. (Courtesy of Michigan Memorial Park.)

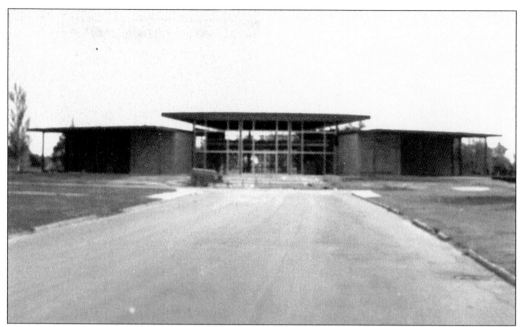

Construction began in the late 1950s. This picture, taken in October 1960, shows the front of the building that would become known as the Shrine of Remembrance. John Heston was the mastermind behind this new building but would not live to see its completion. (Courtesy of Michigan Memorial Park.)

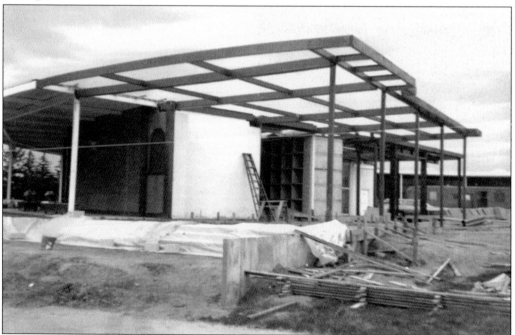

This photograph, taken in 1972, shows the Shrine of Remembrance far from being finished. After her father's death, John Heston's daughter Barbara Heston took over the cemetery's operations. Her attention turned to finishing her father's plan for the mausoleum and chapel. It was completed in 1993. (Courtesy of Michigan Memorial Park.)

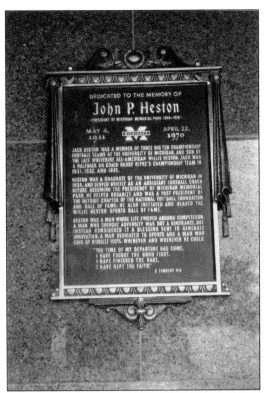

The Shrine of Remembrance, with all its grandeur, is a mausoleum and a chapel. It is one of the largest structures on the cemetery grounds and receives visitors at the end of their drive down the central road. After the building's completion, the remains of John and William Heston, along with the remains of their wives, were placed inside. Memorial plaques admonishing the Hestons' athletic accomplishments, having attended their father's alma mater, hang not far from their crypts. The building has numerous plaques honoring those who were placed in the Willie Heston Sports Hall of Fame.

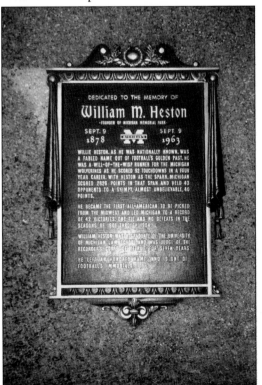

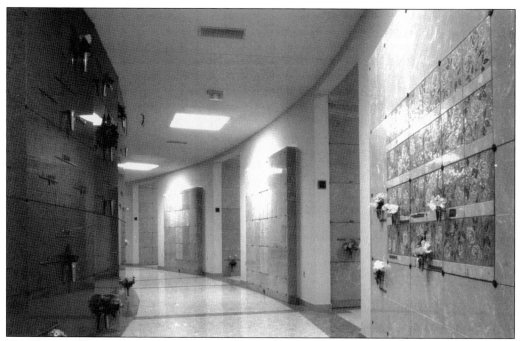

The Shrine of Remembrance has attracted hundreds to be laid to rest here, including those who were cremated. The beautifully designed hallways lead to smaller rooms with stained glass walls accommodating more niches. Some have purchased benches in memory of their loved ones that have been placed throughout the building. (Courtesy of Michigan Memorial Park.)

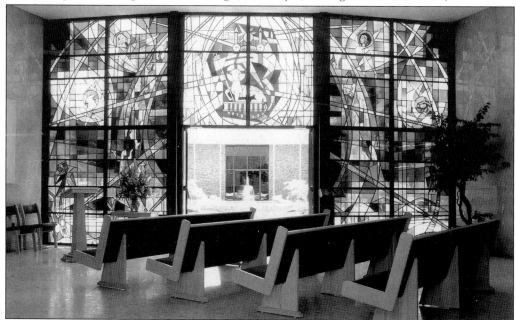

Those wishing to hold obsequies at the cemetery use the chapel area. The stained glass windows, along with the mosaic work throughout the building, were done by the Conrad Pickel Studio in Vero Beach, Florida. The Venetian glass and bronze framed niches were made in northern Italy. (Courtesy of Michigan Memorial Park.)

The very popular Shrine of Remembrance has many walls filled with niches. Some of the niches have colorful mosaic tiles specially made to cover the front panels. The exquisitely designed and delicate floral artwork complements the neutral tones of the walls and floors. (Courtesy of Michigan Memorial Park.)

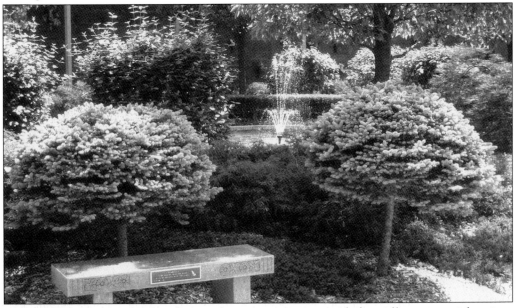

The circular Shrine of Remembrance has a center courtyard that offers more niches in a foliage-filled setting. Complete with memorial benches and a calming fountain, the courtyard offers a place for those wishing to rest and contemplate. This is the way the courtyard once looked. It has since been remodeled but still offers a comforting place to pause and reflect. (Courtesy of Michigan Memorial Park.)

Nestled in a grove of trees that was in existence scores of years before the cemetery was even a thought is the exemplary Woodside Mausoleums section. A canopied area offers a place for services to be held before the remains are placed in one of several mausoleums. Many visitors have enjoyed hearing the rippling of the nearby water, the utterings of a variety of birds, and the cool breezes as they have strolled through the woods on the rambling paved paths. The naturalness of the woods has been left with minor landscaping around the mausoleums. (Courtesy of Michigan Memorial Park.)

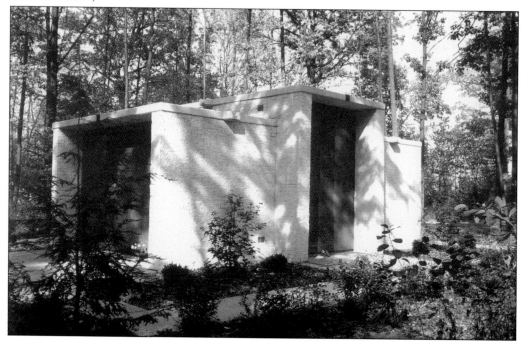

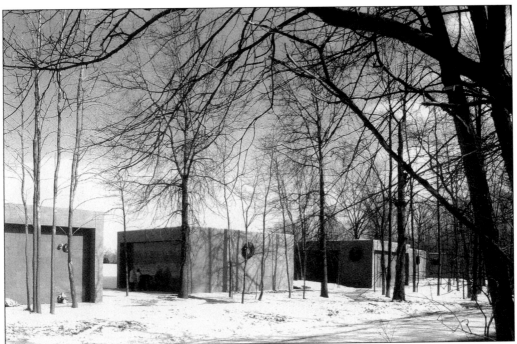

Decorated for the Christmas season with an assortment of greenery, visitors will find that the mausoleums in the Woodside Mausoleums section have taken on a beauty all of their own. In the winter months, exposed by the leafless trees and captured in the sun's rays, one mausoleum catches the reflection of three visitors. (Courtesy of Michigan Memorial Park,)

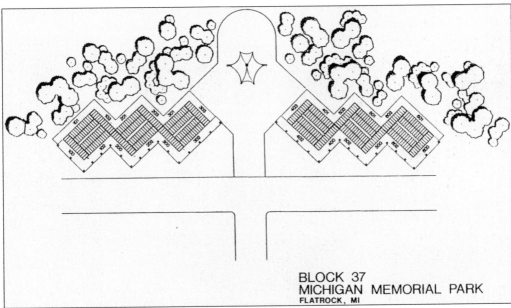

BLOCK 37
MICHIGAN MEMORIAL PARK
FLATROCK, MI

The architect's symmetrical plan of the Arborview Mausoleums, located in block 37 near the Woodside Mausoleums, includes covered walkways around the staggered mausoleums offering protection from the elements, allowing visitors to come most anytime to pay respects to their loved ones. (Courtesy of Michigan Memorial Park.)

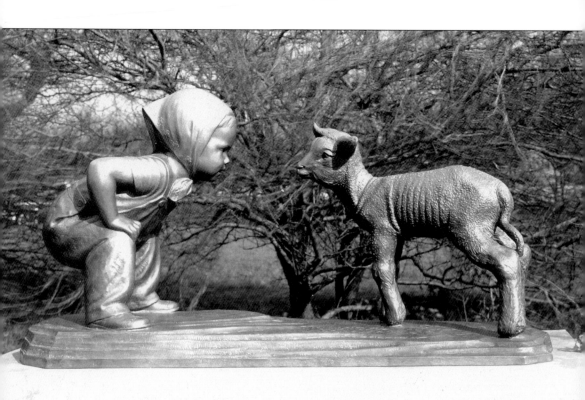

OUR LITTLE LAMBS

Many stunning sculptures grace Michigan Memorial Park's lawns. This endearing bronze figure of a little kerchiefed girl stooping to chat with a lamb welcomes doleful visitors of Babyland, an area reserved for little ones whose lives were taken much too soon. This work of art is attributed to sculptors Florence Gray and Mabel Landrum Torrey who used a design by Leonard Grosse, president of Bronze, Inc. Twin Oaks in block 33 is one of the most visited sections, attracting even those who may not have know the babies, yet want to remember them by leaving a flower on their markers. At one time, this area could not be distinguished in the section, so it was decided that this part needed to be surrounded. In January 1957, the board of directors approved spending $2,300 on a Tennessee stonewall to separate Babyland from the adult graves. (From the collection of David R. Phillips, courtesy of Michigan Memorial Park.)

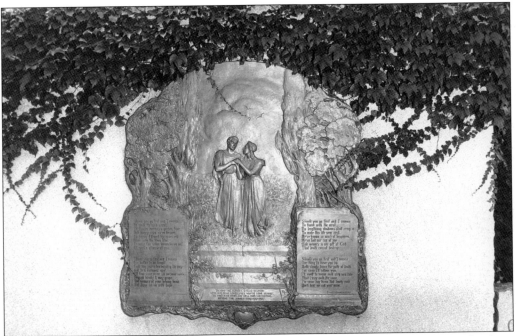

One of the first monuments to be seen upon entering the cemetery is in Companion Gardens. At one time, soft music played at this nine-foot monument with its bronze plaque, sculpted by Otto J. Schweizer in 1952. Visitors to this exclusive section can read the poem on the plaque, *Should You Go First and I Remain*, attributed to Albert Kennedy Roswell. (Courtesy of Michigan Memorial Park.)

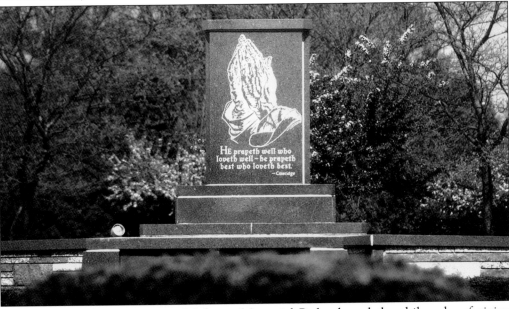

To help those who are grieving, Michigan Memorial Park adopted the philosophy of giving visitors the feeling of hope. In block C, this three-sided granite monument has part of a quotation by Samuel Taylor Coleridge, the 18th- and 19th-century English poet, philosopher, and critic. (Courtesy of Michigan Memorial Park.)

In Lullabyland in block 39, Mabel Landrum Torrey created this bronze monument in the early 1950s. This plaque on the base reads that this is "dedicated to the sanctuary of hope and love—a mother's heart." F. A. Brininstool wrote the poem. (Courtesy of Michigan Memorial Park, photograph by John Heston.)

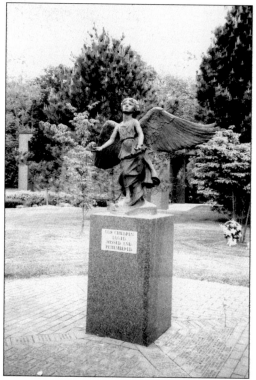

The Christmas Box Angel statue can be found in the Trillium Gardens section of the cemetery. Based on the book *The Christmas Box* by Richard Paul Evans, the angel provides a place to mourn a lost child. Surrounding the statue are paving bricks, memorializing the children who experienced an early death.

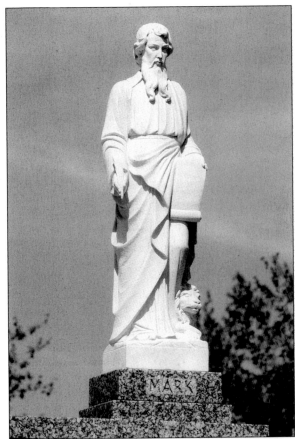

The colossal statues of the four apostles, Matthew, Mark, Luke, and John, adorn the mausoleum in block 22, the Garden of Apostles. Strolling the grounds, visitors can take a breath of fresh air as well as view the overabundance of artwork. As with the statues on this mausoleum, so many of Michigan Memorial Park's sculptures symbolize the hope of what lies ahead for the deceased and helps to reassure those left behind of better things to come. John Heston took the photograph of the statue of Mark. (Courtesy of Michigan Memorial Park.)

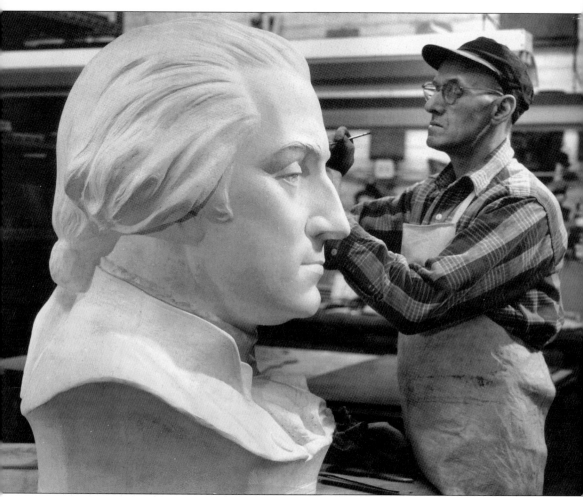

An unidentified artisan works his craft in creating a mold to be used in sculpturing a bust of George Washington that would be used to identify the Masonic Gardens located in block 41 of Michigan Memorial Park. A professional photography company at the time, Kaufman and Fabry Company of Chicago, took this photograph some time in the 1950s or 1960s. No expense was spared to make Michigan Memorial Park the most beautiful cemetery around. Only the best was acceptable in choosing architects, landscapers, and artists who would transfer the former farmland into a place of dramatic splendor. This sculpture would be one of the first to be placed on the grounds. With a few exceptions, most of the cemetery's artwork is bronze. (From the collection of David R. Phillips, courtesy of Michigan Memorial Park.)

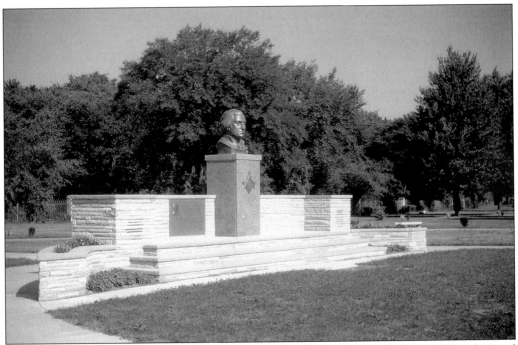

George Washington had been a master Mason, which is the highest rank that could be obtained in the Fraternity of Freemasonry. A popular but secretive group, the Masons encouraged civic responsibility and members were held to a high moral standard. (Courtesy of Michigan Memorial Park, photograph by John Heston.)

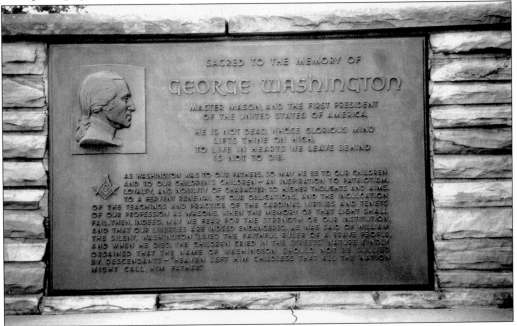

The plaque that accompanies the bust of George Washington helps to explain the main principles of the Masons. Their values and ethics, such as patriotism, loyalty, and nobility of character, coincided with those that William Heston and his family had in developing the cemetery.

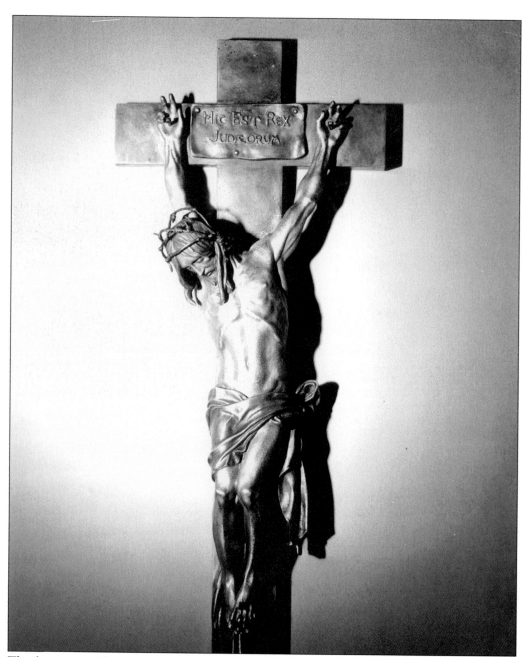

This bronze crucifix was a project of the Trinity Bronze Company in Chicago. Crafted in Italy in the late 1950s, the sculpture is one of the most admired works of art in the cemetery. With life-like details, the over-sized figure is used by many art students who have drawn, painted, and photographed this particular art piece. Sculptures that are made of stone or ceramic are not as strong as bronze and are subject to chipping and cracking. Bronze is popular for sculptures because of the way it expands, filling every tiny crevice during casting. Bronze also holds up well regardless of the elements, and a welcomed patina forms after years of exposure. (From the collection of David R. Phillips, courtesy of Michigan Memorial Park.)

The crucifix was originally placed on a raised garden in the Crucifix Island, block 43, of the cemetery. One of the tallest structures at Michigan Memorial Park, it was easily viewed from anywhere in the cemetery. (Courtesy of Michigan Memorial Park, photograph by John Heston.)

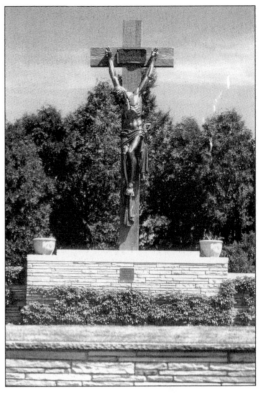

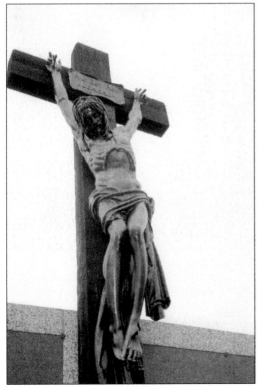

With Crucifix Island redesigned, the crucifix now stands alongside one of the many mausoleums located on the cemetery grounds in Calvary Gardens, block 24. Outdoor masses conducted by local priests are occasionally held, which include memorial services for those who have passed away.

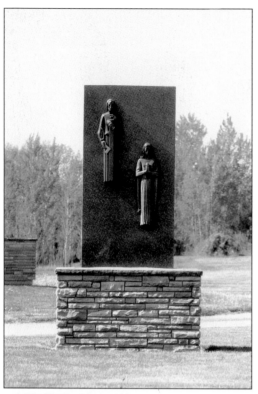

This marble slab with bronze sculptures of Jesus and his mother, Mary, is located in block 26, a small and unnamed section. The methodically designed cemetery makes use of even this tiny patch of land that accommodates several burials. (Courtesy of Michigan Memorial Park, photograph by John Heston.)

Michigan Memorial Park is divided into blocks that are given both names and numbers, some on simple wooden posts. An early brochure boasts the cemetery's spending of nearly $1 million to provide the grounds with horticultural embellishment that helps to refresh the mind of all who come by. Various grasses and day lilies adorn the Trillium Gardens sign located in block 28.

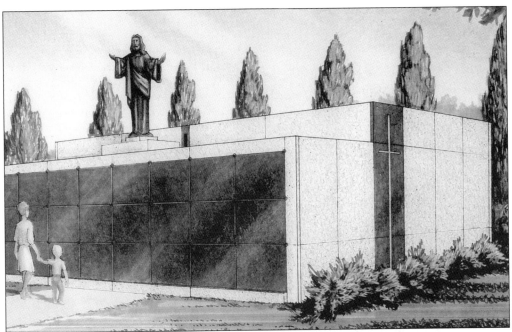

The architect's rendition of a proposed mausoleum to be located in a second section called Companion Gardens located in block 39 was accepted and built complete with the suggested shrubbery. Since the founding of Michigan Memorial Park, an unwavering goal of the cemetery has been to make sure a balance was kept between the architecture and the natural surroundings. Neutral colors and natural stone help the relatively low built mausoleums add delicacy to the place of repose. Its harmonization within the layout gives it an unpretentious appeal. (Courtesy of Michigan Memorial Park.)

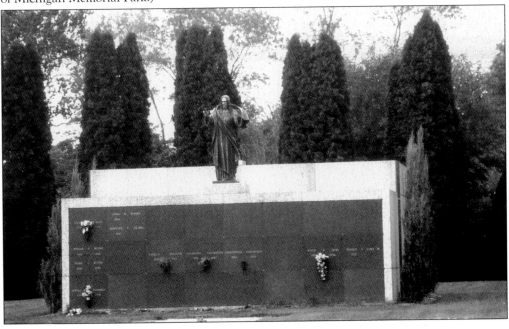

The first known inhabitants of this area were members of the Wyandott tribe, also spelled Wyandot or Wyandotte. Chief Quoqua and his tribe settled here along the Huron River in the early 1800s, after receiving a 50-year lease from Gen. Lewis Cass, the territorial governor of Michigan at that time and who was acting as the Native American commissioner. He scouted out the northwestern part of Michigan while studying Native American languages. Examining their culture, he became sympathetic to the Native American tribes but was still able to convince them to cede their lands. In 1926, the Board of County Parks trustees erected a monument on the Huron River paying tribute to the Native American tribe and its leader who stayed in this area until the early 1840s. (Courtesy of Michigan Memorial Park.)

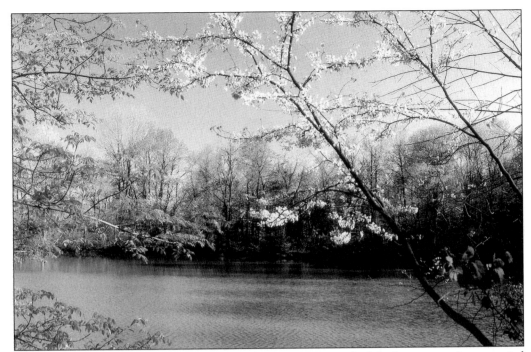

In honor of Chief Quoqua who died in 1822, the monument marked the last reservation occupied by the tribe from 1818 to 1842. The monument honoring the Wyandott tribe originally was located along the Huron River, pictured here. (Courtesy of Michigan Memorial Park.)

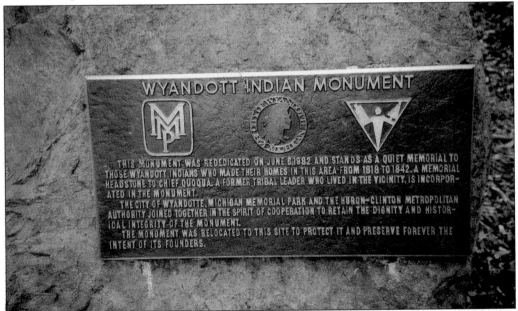

In 1982, Michigan Memorial Park became aware that the monument had been vandalized and was quickly deteriorating. The cemetery, together with the City of Wyandotte and the Huron-Clinton Metropolitan Authority, restored it, moved it to the cemetery, and rededicated it. The plaque is attached to a boulder located near the monument located in the Woodside Mausoleums section.

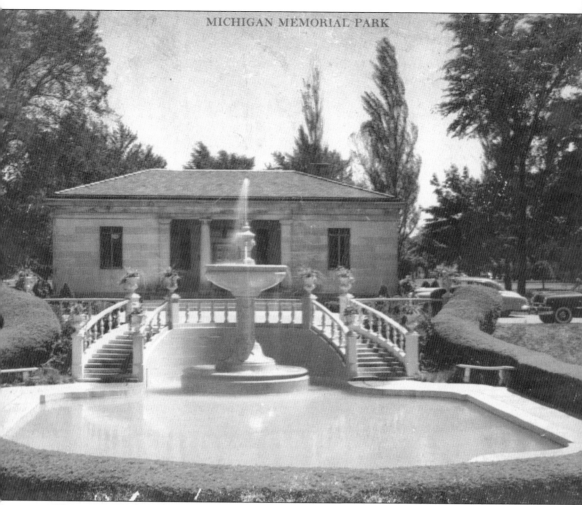

This timeworn booklet was produced for a special memorial program in the mid-1950s Michigan Memorial Park held for the deceased residents of Lincoln Park, Michigan, who had been buried at the cemetery. It listed the names of the deceased, birth and death dates, the location of the graves, and the name of the funeral director. It also gave a brief history of Lincoln Park, noting that until 1921, Lincoln Park was part of Ecorse Township. Most of the residents were descendants of French pioneers who had settled in the area in the 1790s or of German immigrants who came in the mid-1800s. Noah LeBlanc had owned a general store at Fort Street and Southfield Road in the late 1800s. Herman Quandt would late open a bread store and then a saloon sometime later at the same spot. Farming was the main source of income until Henry Ford built his automobile factory on the Rouge River, encouraging many people to move to the area. (Courtesy of Michigan Memorial Park.)

:VELOPMENT work started in the Spring of 1927. Our progress h
continued with the result that to date over three quarters of a milli
rs have been spent (and paid for) in making MICHIGAN MEMORIA
K the outstanding achievement of the entire Middle West.

tal acreage, 178 acres, of which approximately 140 acres will be us
urial. Balance to be used for Park reserve, sunken gardens, lakes ai
s. The average size family lots are for six graves, containing tv
lred square feet (10 feet by 20 feet). Family lots from two to twel
es are also available.

fund of approximately $500,000.00 will provide for the upkeep and ca
ery grave forever, at no additional cost to the owners of burial sectior
infinite pains this Perpetual Care Fund is safeguarded. This Perpett
Fund is your assurance of Perpetual Beauty. There are no taxes
sments, nor extra charges for improvements or perpetual care.

U undoubtedly are adequately protected by insurance. Your will
lrawn as another measure of protection. Do you own your cemete
This provision for an inevitable necessity should be attended to NOV
e the minds of father and mother, husband and wife, are free fro
ssing grief. Now is the time for you to frankly discuss this matt
each other, and to secure a place of beauty for the last resting place
self and loved ones. Choice locations are available at the present tin
etery prices are sure to advance. Terms may be arranged now to
budget. Why delay? Fill out and mail the enclosed card for furth
mation.

MICHIGAN MEMORIAL PARK, INC.

m N. Heston, President FLAT OCK, MICHIGAN John P. Heston, Secreta

S rling 2-3177

F m Martin, Sales Manager Harvey W. Brick, Public Relations

Containing names like Karamanos, Labadie, Meschke, Hetterscheidt, Cicotte, and Navarre, the booklet continued to tell of Lincoln Park's development of being called "Tent City" and "Mudville" due to the tar paper shacks and muddy roads that were caused by the rapid growth to the area. Housing and roads could not be built fast enough to accommodate new residents coming to work in the new Ford factory. In 1921, Lincoln Park became a village. Four years later, the village was incorporated into a city. The population had increased from a little over 12,000 in 1930 to about 48,000 at the time of this memorial service. Seeing this as an opportunity for the cemetery to show the importance of pre-planning, the back cover of the booklet expresses the advantages of choosing Michigan Memorial Park as one's final resting place. (Courtesy of Michigan Memorial Park.)

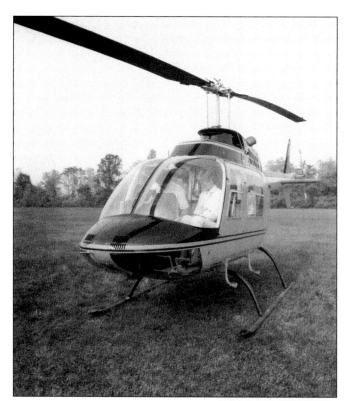

When business savvy John Heston became more involved with pre-need selling of cemetery property, he wanted to make sure buyers would be totally satisfied with their choice of plot location. Riding high over the cemetery grounds, the entire cemetery could be viewed in a matter of minutes. (Courtesy of Michigan Memorial Park.)

Heston is shown in this undated photograph, ready to accompany an unidentified couple ready to choose their final resting place. Heston was also an amateur photographer. Many of the photographs in this book were printed from slides he had taken of the cemetery. (Courtesy of Michigan Memorial Park.)

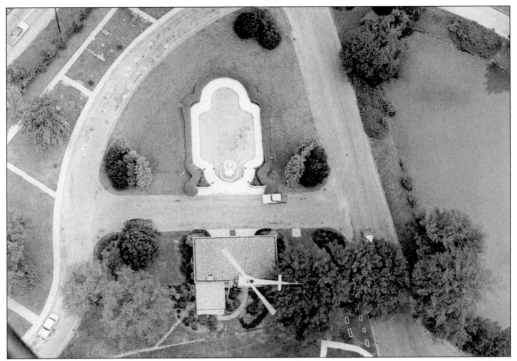

Flying over the administration building located near the entrance of Michigan Memorial Park, the helicopter escorted hundreds to pick the best spot to be buried. The idea seemed good and many were pleased to have this opportunity, but it lasted only about a year before the cemetery ended this practice. (Courtesy of Michigan Memorial Park.)

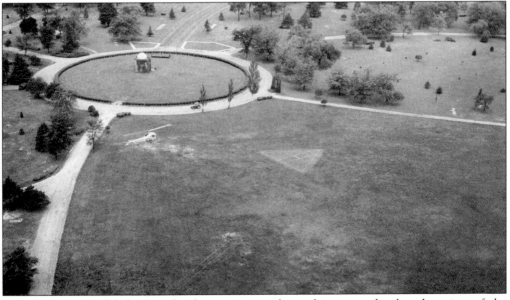

The three-cornered helicopter landing space was located in an undeveloped section of the cemetery. Although many sales of cemetery property were made this way, people were just as pleased to make their selection by walking the grounds. The replica of Rachel's Tomb is seen in the upper left of this undated photograph. (Courtesy of Michigan Memorial Park.)

In this undated photograph, John Heston, standing in the middle with others who are unidentified, would hold several positions in the company until finally being elected president in August 1958. Under his direction, additional land was purchased, increasing the cemetery property to its present 300 acres. His father, William Heston Sr., remained involved in the cemetery as chairman of the board. His brother, William Heston Jr., served as the board's secretary. By this time, the board of directors meetings were no longer held in Detroit but at 5871 Pelham Road in Allen Park. In 1963, it was decided that board members be compensated $100 per meeting that they attended and that John receive a yearly salary of $6,000 as president. His brother William would be paid $1,000 a year as secretary. (Courtesy of Michigan Memorial Park.)

With John at the helm, the cemetery's reputation mushroomed. One of his goals was that no grave should go unmarked. Waiting several years after a burial, if the deceased's family still could not afford to pay for a headstone, John would order one himself and place it on the grave. (Courtesy of Michigan Memorial Park.)

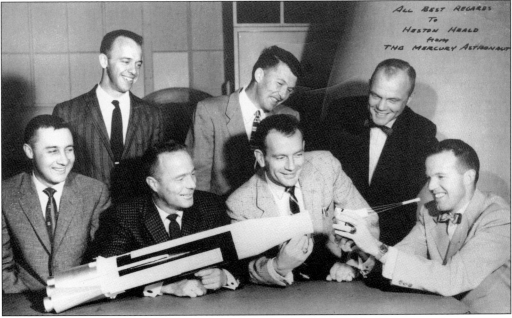

For a short while, John published a newspaper, the *Heston Herald*. He came to know quite a few influential people during his tenure as president of the cemetery. In 1959, NASA's Project Mercury was introduced to see if human beings could survive in space. The astronauts in this undated photograph were selected for this program. (Courtesy of Michigan Memorial Park.)

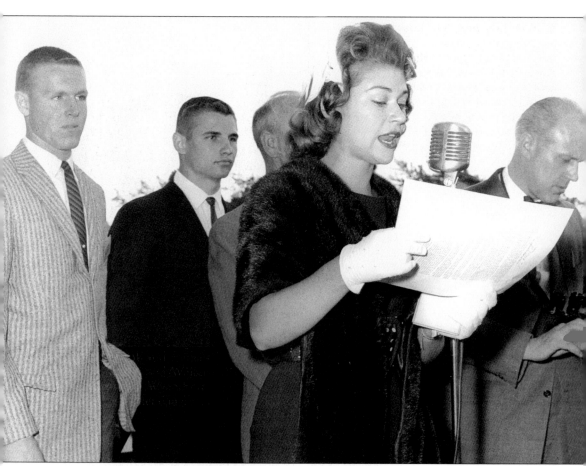

Michigan Memorial Park strengthened its relationship with the community by making donations to civic groups and sponsoring their own scholarship programs. Fur-draped Ann Marston, archery champion and the 1960 winner of the Miss Michigan pageant, is seen in this undated photograph helping to present the Willie Heston Scholarship. In 1957, the cemetery had sponsored the Flat Rock Legion Drill Team at the cost of $1,500. Many $1,000 scholarships had been given to local high school students through the years. The Flat Rock Garden Club received monetary donations plus the use of various areas of the cemetery to be used for flower gardens. Blood drives, photography contests, outdoor masses, and other community-minded activities have continued to carry on the traditions and visions once held by the original founder, William Heston. (Courtesy of Michigan Memorial Park.)

In 1969, John Heston (center), past president of the Allen Park Kiwanis Club, stands with members of the Taylor and Allen Park Kiwanis clubs. A contest was held between the two clubs and the loser, the Taylor club, had to pay the Allen Park group $100. With 10,000 pennies in the wheelbarrow, the Allen Park club used it to ready 80 acres of the cemetery property to be used as a campsite for young people. (Courtesy of Michigan Memorial Park.)

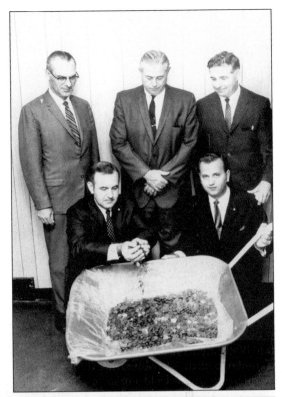

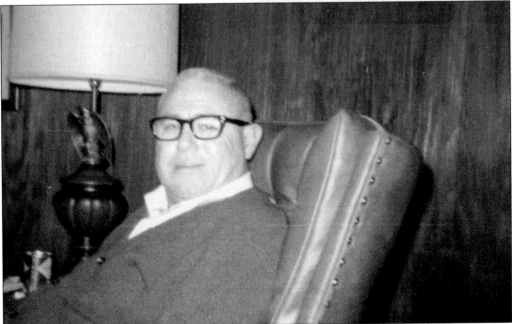

While president of Michigan Memorial Park, John Heston reached out to many non-profit and charitable groups. Many would benefit from his generosity in donating his time, money, and usage of cemetery property to further their causes. This photograph of Heston was taken in 1969. (Courtesy of Dot Trayes.)

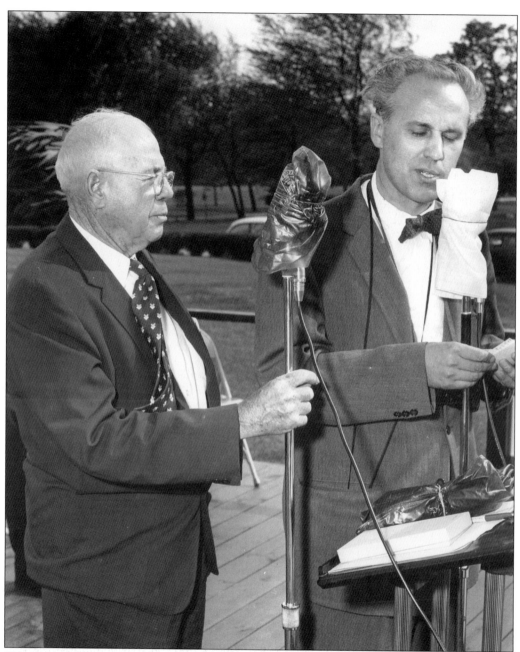

Whether sponsoring scholarship award ceremonies or other public activities, Michigan Memorial Park was never without the participation of Michigan notables. In this undated photograph, William Heston Sr. (left) is joined by G. Mennen Williams, nicknamed Soapy. Williams's grandfather Gerhard Heinrich Mennen was the founder of the Mennen brand of health care products. Named in part after his grandfather, Williams was given the moniker of Soapy. Serving in the U.S. Navy in World War II, he held the position of air combat intelligence officer in the South Pacific. Williams also served Michigan as governor from 1949 to 1961. He went on to become the U.S. ambassador to the Philippines from 1968 to 1969. (Courtesy of Michigan Memorial Park.)

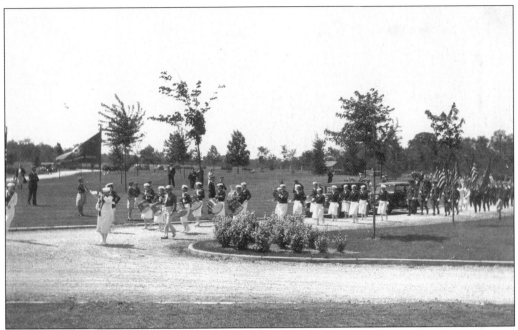

From the cemetery's birth, one of the most important contributions that Michigan Memorial Cemetery made to the community was offering an annual Memorial Day celebration. Known in the cemetery's early years as Decoration Day, this yearly event brought out hundreds of people in nearby neighborhoods. With great dignity and respect, the cemetery offered hours of honoring all those who had fought for their country. With marching bands, military exercises, and speeches made by local and state dignitaries, rain or shine, people arrived early and stayed late during this salute to the military. (Courtesy of Michigan Memorial Park.)

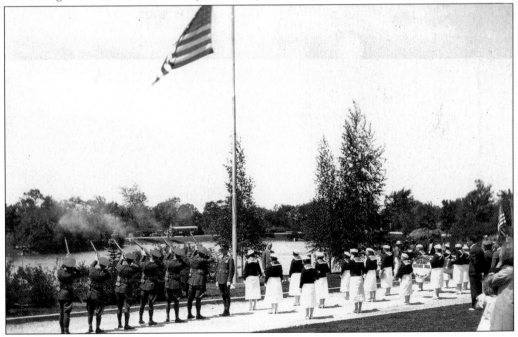

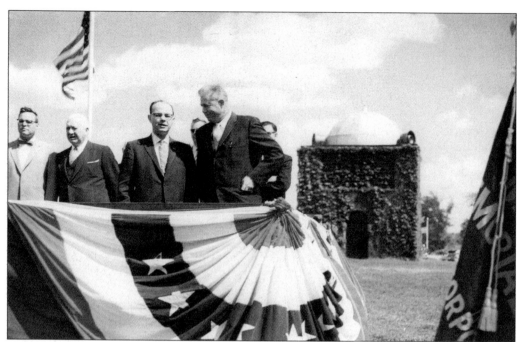

John Heston, second from right, joins other unidentified dignitaries on the flag-draped platform during a Memorial Day celebration in this undated photograph. The ivy-covered replica of Rachel's Tomb is seen in the background. Eventually this would become the spot where the Shrine of Remembrance would be built. (Courtesy of Michigan Memorial Park.)

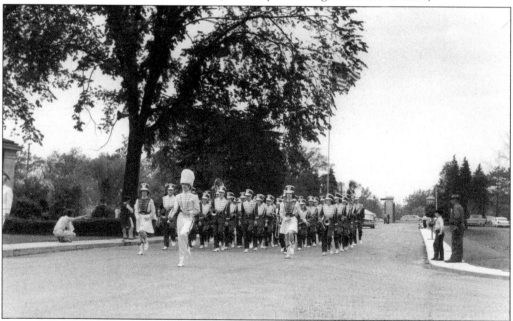

Local high school marching bands would be called upon to participate in the Memorial Day parades. Back when majorettes' skirts were barely above the knee, the undated photograph of this group was taken just as they entered the main entrance of the cemetery. (Courtesy of Michigan Memorial Cemetery.)

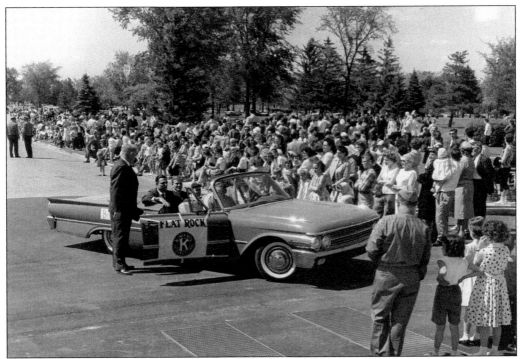

Local non-profit groups helped the cemetery in its celebrations. This Memorial Day event shows John Heston, standing near the automobile, greeting the arrival of the Flat Rock Kiwanis. The Memorial Day festivities would draw the biggest crowds of any of its events to the cemetery. (Courtesy of Michigan Memorial Park.)

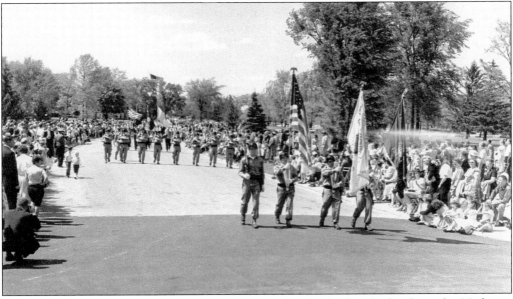

The main road in the cemetery is flanked on both sides by hundreds of people. Michigan Memorial Park spared no expense in putting on a good show. A total of $3,000 was spent in 1957 for ceremonial expenses plus an additional $255 was used to purchase rain insurance. (Courtesy of Michigan Memorial Park.)

When the United States became involved in World War II, bronze markers could no longer be produced. The bronze headstones required copper, which was an instrumental material used in the war efforts. So in place of bronze markers, Matthews International Corporation, the maker of the markers used by Michigan Memorial Park, made temporary ones from asphaltum to mark the graves. The American Hard Rubber Company in Akron made this mixture of asphalt and rubber. Made to look like bronze, these markers would be replaced with bronze ones after the war ended. In 1954, the cemetery's board of directors agreed that the bronze markers would be required to be composed of a minimum formula of 87.4 percent copper, 5.25 percent tin, 2.26 percent lead, .13 percent iron, .07 percent antimony, .5 percent nickel, .03 percent sulphur, and 4.36 percent zinc, with no usage of manganese, aluminum, or silicon.

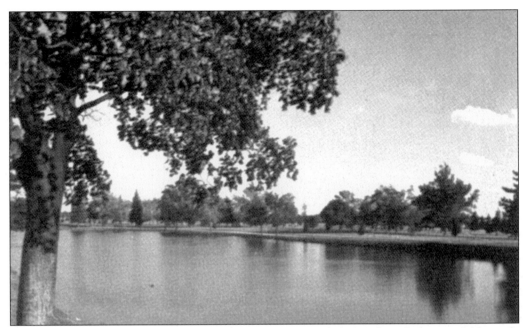

This little card featuring Michigan Memorial Park's crystal clear Sylvan Lake was deliberately left blank on the reverse side. It was given to visitors who could use it as a memento after visiting the cemetery or to record such things as loved ones' grave locations. (Courtesy of Michigan Memorial Park.)

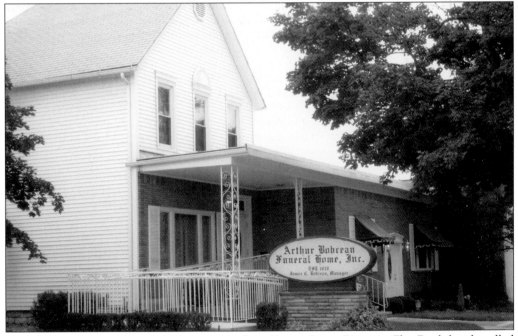

The Arthur Bobcean Funeral Home located on Huron River Drive in Flat Rock has handled hundreds of burials at Michigan Memorial Park. Opened in 1939, Arthur and Ethel Bobcean would run the business until their sons took over. Arthur had joined his father, Edward, who had a funeral home in Detroit, founded in 1910.

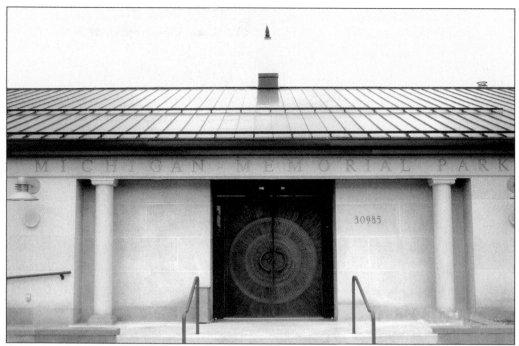

A second administration building was constructed when more staff was added, overcrowding the first administration building. The original building is used by the family counselors, with this one used by administrators. This is also where the records of the deceased are microfilmed and stored. (Courtesy of Michigan Memorial Park.)

The logo of Michigan Memorial Park, with its intricate design, is displayed on the iron fence surrounding the cemetery. The formal entrance with its bronze plaque welcomes visitors into its harmonious surroundings. (Courtesy of Michigan Memorial Park, photograph by John Heston.)

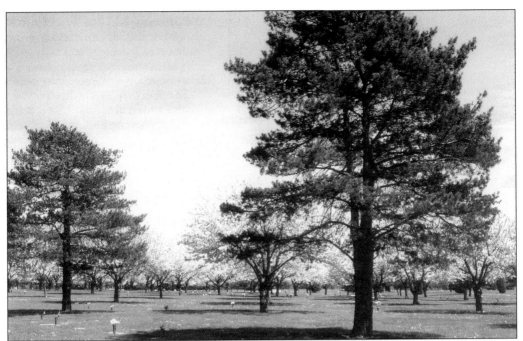

Burgeoning trees, neatly trimmed shrubs, and efflorescent flowers surround the 13 mausoleums on the grounds creating one of the most impressive cemeteries around. Springtime opens the door for a rainbow of vivid colors to flood the cemetery grounds. Bouquets left in memory of loved ones conform to the cemetery's wishes of maintaining the park-like ambience and add to the kaleidoscope of color. Deliberately planted trees separate family plots. Fringed with woods and open fields that an assortment of animals call home, Michigan Memorial Park is frequently visited by their inhabitants. (Courtesy of Michigan Memorial Park, photograph by John Heston.)

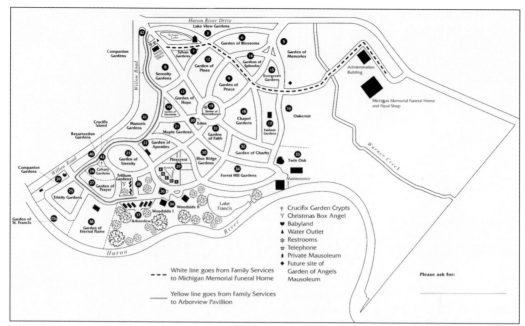

This is the cemetery as it looks today. With additional property acquired after the initial purchase, the cemetery is now landlocked. With over 64,000 burials, Michigan Memorial Park has room to accommodate many more thousands. The webwork of winding roads and wooded burial sites exceed mediocrity in its design. (Courtesy of Michigan Memorial Park.)

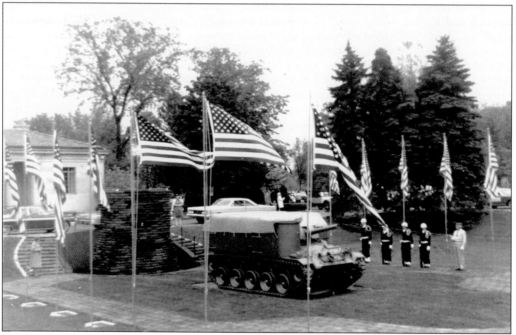

For quite a few years, an army tank stood watch in the area, recognizing those who served in the military services. Surrounded by an abundance of U.S. flags, it was a focal point during the Memorial Day celebrations held each year at the cemetery. It was later moved to the VFW hall in Carleton. (Courtesy of Michigan Memorial Park.)

Three

COMMON PEOPLE, UNCOMMON LIVES

Some Michigan cemeteries date back to the mid-1800s, so when Michigan Memorial Park opened, many of Michigan's notables had already claimed other burial grounds for their final resting place. Michigan Memorial Park attracted area residents who earned their living through farming and working in factories. They were not household names except to their families and neighbors, but their headstones recall names like Laginess, Amiot, Bahlhorn, Cousino, and Lezotte who helped establish Huron Township and its surrounding areas. The cemetery broke ground when a new decade would bring death and despair. Heat waves, epidemics, and the Great Depression seemed to control everyone's fate. It would take time for the community to recover, but they would attest later to just how happy they were to have survived. It was a time of neighbor helping neighbor, and struggling to make ends meet was part of the daily routine. Fortune would shine on some and their lives would go down an unexpected but welcoming path. For others, they learned to be content with what they had and be grateful they had made it through another day. Michigan Memorial Park would receive them all. Flowers are still placed on graves of infants who lived only one day in the first few years after the cemetery opened. Parents still mourn their children who perished in a freakish carnival accident years ago. Some place flowers on headstones of the famous as a tribute to their accomplishments they could only dream about. Memorials are left for those whose tragic stories touched the lives of people they did not know. Unadorned graves mark the sites of lost or forgotten relatives. But buried with every soul are tales of broken hearts and of living happily ever after, of making bad choices and of getting lucky breaks, and of passing life expectancy and of not living long enough to change the world. Some stories would be shared with relatives and neighbors. As years passed, the stories would change or be buried with the past. But many stories have become fresh again, and the memories of those once forgotten are now remembered.

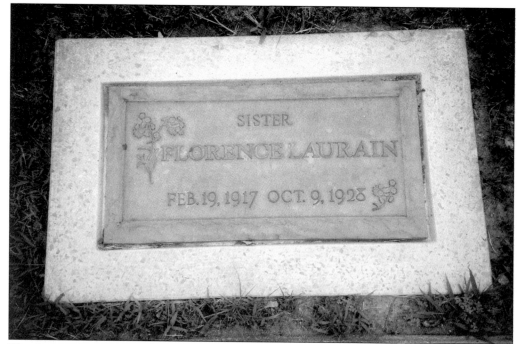

The first interment at Michigan Memorial Park was that of little 11-year-old Florence Laurain. Born February 19, 1917, she was the eighth of 13 children who came from a long line of pioneers. The first Laurain family, also known as Lorrain and Laura, came from Montreal in 1783. Joseph Lorrain had married Mary Louisa Dagenais, and they settled on 140 acres located on the River Rouge in what is now Detroit near the Gen. George Patton Park. Their offspring would branch out and Florence's family settled on a farm on Willow Road not far from the cemetery. Florence had accompanied her older brother outside to watch him shoot pigeons with his 12-gauge shotgun. As he was loading the gun, it accidentally discharged taking her life instantly on October 9, 1928. Her grave is in Sylvan Gardens, block 7. In 1956, descendants of the Lorrain family placed a dedication marker in the family plot honoring Joseph.

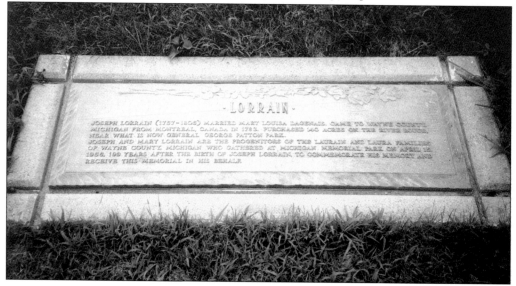

Edward M. Ramirez was of the first generation to be born in the United States. His parents, Rafael and Josephina, came to Michigan from Mexico City after they married. Ramirez married his sweetheart, Carolyn Herrera, and they traveled to New York shortly after their wedding in August 1960. As teenagers, they lived in the same neighborhood, and Carolyn caught his eye as she walked home from school each day. (Courtesy of Pamela Ramirez.)

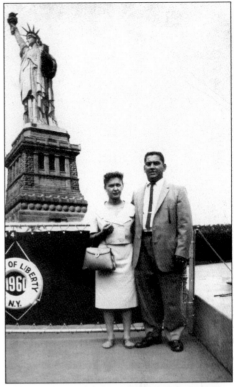

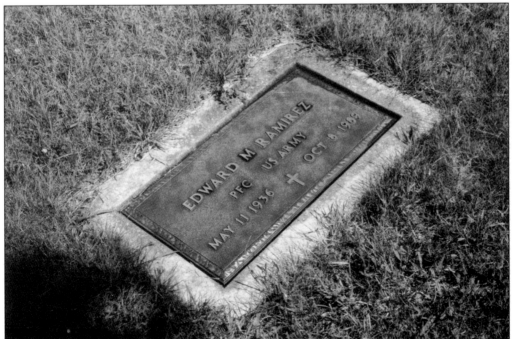

One of six children, Edward went on to have three children of his own. For over 30 years, he worked for the Kroger Company Warehouse Distribution Center in Livonia, only interrupted by his serving in the U.S. Army for two years. He is buried in Lake View Gardens, block 3.

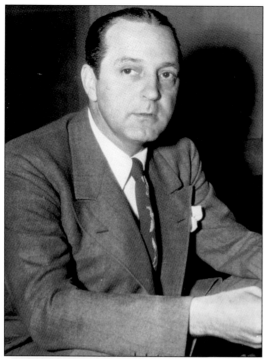

One of Michigan Memorial Park's well-known grave sites belongs to Preston Tucker. He was the producer of the 1948 Tucker Sedan, also known as the Tucker Torpedo. His Chicago company built 51 automobiles before closing its doors on March 3, 1949. Tucker was found innocent after he had been indicted on federal charges of mail fraud and violation of the SEC law. (Courtesy of Ricardo Iraheta.)

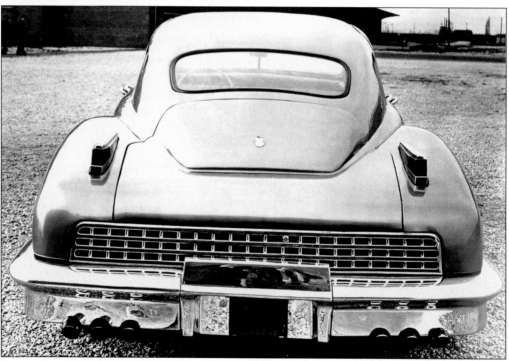

An automobile that would be like no other, Tucker planned the model, with Alex Tremulis adding the final touches to the design. It would incorporate features unheard of at that time, such as a rear engine and fuel injection. At auction, the automobiles have fetched as much as $700,000. (Courtesy of Ricardo Iraheta.)

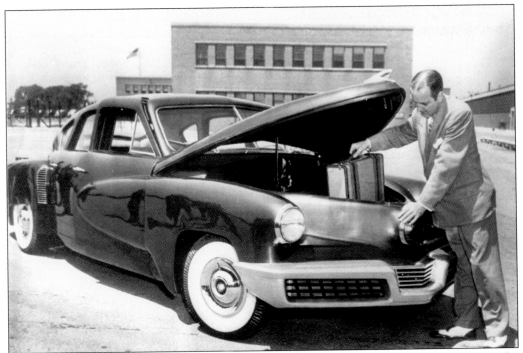

Wherever Tucker took his sedans to show, they became an instant hit, especially when he demonstrated placing a suitcase under the hood. Ordering one of his automobiles could also include adding accessories like a radio. Hollywood's George Lucas and Francis Ford Coppola told Tucker's story in the 1988 movie *Tucker: The Man and His Dream*. (Courtesy of Ricardo Iraheta.)

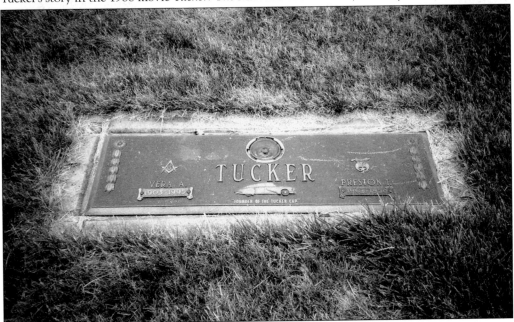

Tucker died in 1956 at the young age of 51, one year for each car he made. He is buried in the Masonic Section, block 41. The company failed after his firm's executives had been charged with fraud. Even though the charges were later dropped, the bad publicity ruined his image.

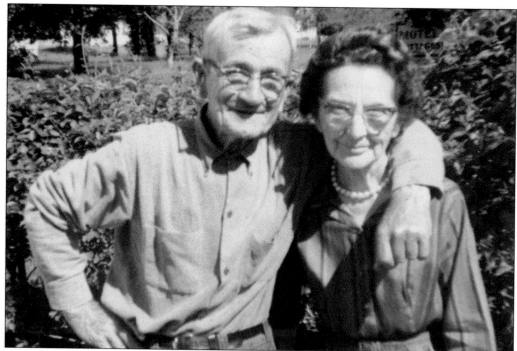

German native Otto Carl Linstead was born on October 20, 1887, and immigrated to Michigan as a child. He and his future wife, Mary Jane, grew up in Port Huron. As an adult, Otto worked as an oiler for the Great Lakes Engineering Works in River Rouge. (Courtesy of Gary Powers.)

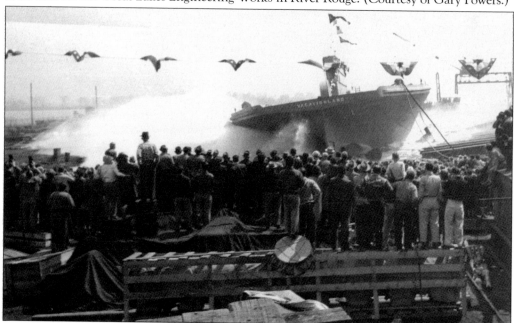

A crowd stood in awe as the *Vacationland* was launched on April 7, 1951. Costing the Great Lakes Engineering Works $4,745,000 to build, it sank in a storm December 3, 1987, not far from British Columbia, as it made its way to Japan. It remains on the bottom of the Pacific Ocean. Otto was instrumental in its construction. (Courtesy of Gary Powers.)

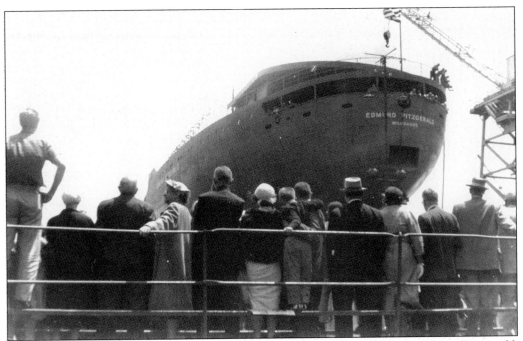

Otto acted as hull foreman when the Great Lakes Engineering Works built the *Edmund Fitzgerald*. Making its debut in June 1958, the bulk freighter would always be remembered when it sank in Lake Superior on November 10, 1975. Encountering a storm and taking on water, the ship went down, taking its 29 crew members with it. (Courtesy of Superior View.)

Otto passed away on July 2, 1970, gone before both ships met their fate that he helped build. He is buried in the Garden of Saint Francis, block 25A next to his wife, Mary Jane, who died July 15, 1977. Residents of Ecorse, Otto's life-long occupation was working in the River Rouge shipyard.

Three years after being discharged, U.S. Army soldier John Henry Ziegler took Vivian Gladys Teeters to be his wife on March 19, 1949. The postwar wedding took place in Wyandotte. One of 11 siblings, John was joined by three brothers to serve in World War II. (Courtesy of Vivian Ziegler and Denice Snyder.)

Born in Massilon, Ohio, John enlisted in the army on February 11, 1943. Sitting at the Post Head Quarter Mail Center at Camp McCoy, near Sparta and La Cross, Wisconsin, 20-year-old Ziegler had been a duplicating machine operator before serving in the military. (Courtesy of Vivian Ziegler and Denice Snyder.)

53227

CERTIFICATE IN LIEU OF LOST OR DESTROYED

Honorable Discharge

This is to certify that

JOHN H ZIEGLER 36 570 364 Technician Fifth Grade
Detachment A 11th Traffic Regulation Group

Army of the United States

was Honorably Discharged from the military service of the United States of America at Camp Atterbury Indiana

on 23 April 1946

This certificate is awarded as a testimonial of Honest and Faithful Service to this country.

Given at the War Department, Washington, D. C., on 30 June 1947

By order of the Secretary of War

Adjutant General

This certificate is given under the provisions of the Act of Congress approved July 1, 1902, "to authorize the Secretary of War to furnish certificates in lieu of lost or destroyed discharges" to honorably discharged officers or enlisted men or their widows, upon evidence that the original discharge certificate has been lost or destroyed, and upon the condition imposed by said Act that this certificate "shall not be accepted as a voucher for the payment of any claim against the United States for pay, bounty, or other allowances, or as evidence in any other case."

NOTE.—This certificate is issued from the office of The Adjutant General of the Army without erasure. Any addition, alteration, or erasure made thereon is unauthorized.

John received an honorable discharge on April 23, 1946, at Camp Atterbury, Indiana. While two of his brothers fought in the Battle of the Bulge, John was stationed in Germany. The Germans had a technique of stringing wire across the roads to kill unwary soldiers as they drove. Driving a military jeep one day, John ran into one of the unsuspecting wires. The wire hit the windshield first, giving him a fragment of a second to duck, and avoid being decapitated. With only broken glasses and a scratch, he survived. Finishing his enlistment as a Technician Fifth Grade, John passed away in 1997 and is buried in the Shrine of Remembrance, block 19C. He received the American Theater Ribbon, the EAME Ribbon, the Good Conduct Medal, and the World War II Victory Medal. (Courtesy of Vivian Ziegler and Denice Snyder.)

1933

Robert Toth grew up on Post Avenue in what had been an area known as Delray. This was a blue-collar neighborhood located on the southwest side of Detroit that had been incorporated as a village in 1897 and was later annexed by Detroit in 1906. (Courtesy of Rose Butka Toth.)

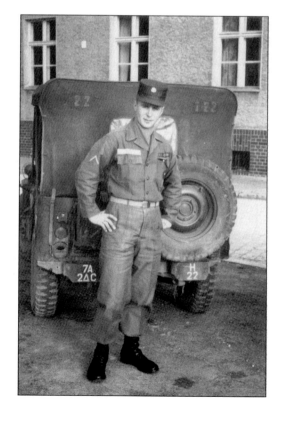

Leaving his brother and widowed mother behind, Private First Class Toth joined the army in 1957 and was stationed in Germany the entire time. In this photograph taken in May 1959, the Hungarian is getting ready to go on guard in Stuttgart. (Courtesy of Rose Butka Toth.)

Toth married the former Rose Butka, whose family owned the Hungarian Kitchen, one of Wyandotte's favorite restaurants that had served the community for decades. Introduced to her by his cousin, he took her to watch him play baseball in River Rouge on their first date. (Courtesy of Rose Butka Toth.)

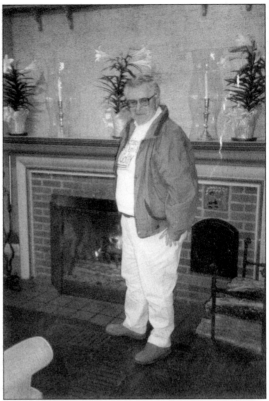

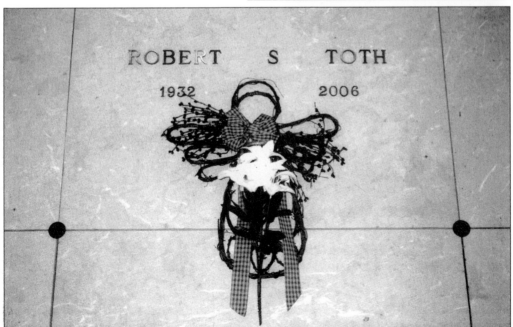

Robert would work in quality control for General Motors at the Willow Run plant for 34 years before retiring. A big Detroit Lions fan, he held season tickets for over 40 years. He was laid to rest in the Shrine of Remembrance in block 19C.

German native Heinz C. Prechter would become one of the area's most recognized citizens in the Downriver area. As a student at OHM Polytechnic Engineering School in Nuremburg, Prechter then studied at San Francisco State College as an exchange student in 1963. While there, he started installing automobile sunroofs, something new to drivers in the United States but very well received. (Courtesy of American Sunroof, Inc.)

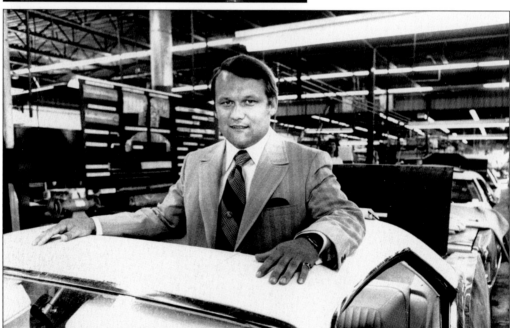

Just a little over two years later, Prechter founded the American Sunroof Company with $764 worth of equipment, including a sewing machine found in a junkyard. Starting with sunroofs and expanding the business with additional products and services, his company grew to be a multimillion-dollar leader in its industry. (Courtesy of American Sunroof, Inc.)

Because of his success, Prechter received numerous awards including Entrepreneur of the Year by the Harvard Business Club and Crain's Detroit Business 1988 Newsmaker of the Year. He shared his wealth with the Boy Scouts of America, the Michigan Cancer Foundation, the Holocaust Memorial Center, and a host of other charitable groups. (Courtesy of American Sunroof, Inc.)

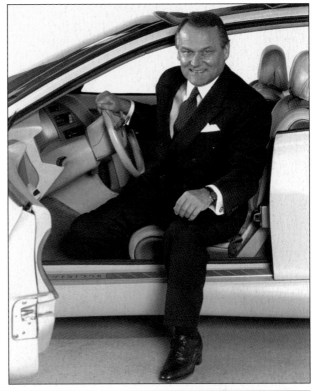

Prechter became a United States citizen in 1972, and in 1999, he was awarded the Ellis Island Medal of Honor. He also owned a string of weekly newspapers, a real estate development company, and a beef cattle business. Prechter was 59 years old when he died July 6, 2001, and is buried in Oakcrest, block 16.

This photograph, taken around 1908 of the Kowaleski family, shows parents Frank and Frances (seated) surrounded by their children, from left to right, Helen, Mary, Stanley, and Walter. Frank, a master blacksmith, was employed at the Michigan Alkali Company in Wyandotte. Frances, a talented seamstress, sewed most of their clothing including the dresses her daughters are wearing in this photograph. (Courtesy of Beth Kowaleski.)

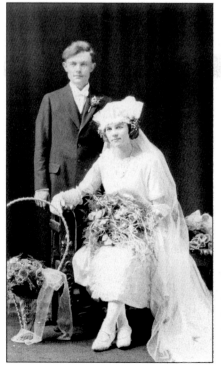

Walter married Lottie Szejda. He worked at the Wyandotte Light and Water Department. Wyandotte became one of the first cities to have both an electric plant and a water filtration plant. Walter worked at the filter plant at the foot of Vine Street. In 1927, Vine Street was changed to Vinewood Avenue to help the fire department distinguish the names Pine Street and Vine Street when answering emergency calls. (Courtesy of Beth Kowaleski.)

Located not far from the automobile plants in Dearborn and nearby towns, Wyandotte would be one of the cities that would attract many residents because of its locality. Walter and Lottie were married in 1923. Lottie's father built them a store as a wedding gift and Walter and Lottie leased the main floor of their store to the Atlantic and Pacific Tea Company, now known as A&P. They lived with their family in a flat above the store, which was typical of many families owning their own businesses. The Kowaleskis are buried in the Garden of Eternity, block 23.

Anna Lauka Snyder Kontur was born September 24, 1899. She was first married to Andrew Snyder and then to Andrew Kontur. Coming to the United States in 1913, she left the Slovak area of Czechoslovakia, but always remained true to her homeland by wearing her native dress. (Courtesy of Jeanette Snyder.)

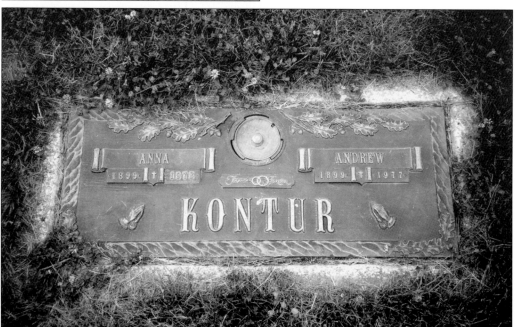

Andrew Kontur, Anna's second husband, was born in Hungary in 1899 and fled during World War I on the S.S. *George Washington*. First living in Canada and then moving to the United States, he would meet his future bride and settle in River Rouge. They are buried in the Garden of Peace, block 9.

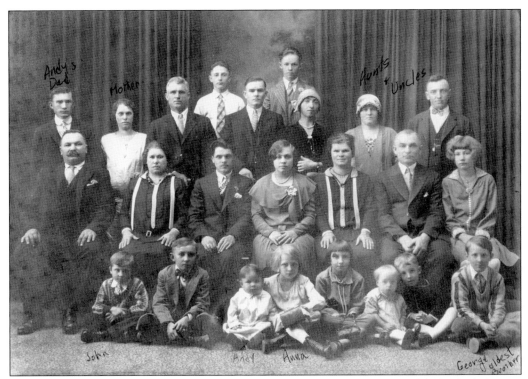

Anna is pictured with her first husband. She stands in the third row, second from the left, next to her husband, Andrew Snyder Sr. on the left. Their four children, John, Andrew Jr., Anna, and George are seated on the floor in the first row. (Courtesy of Jeanette Snyder.)

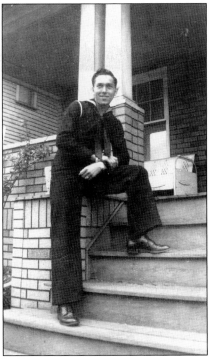

Andrew Jr. entered the navy just as World War II was ending. Here he stands on the steps of the house his mother used to rent to boarders. He loved to polka and when he was courting his future wife, Jeanette Katterman, they frequented the area dance halls. He passed away October 5, 2002, and is buried in block 28C. (Courtesy of Jeanette Snyder.)

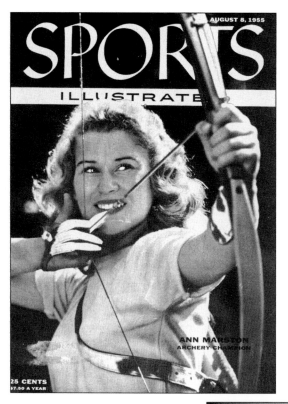

England's native and Michigan's darling, Ann Penelope Marston, a world champion archer, appeared on the August 8, 1955, cover of *Sports Illustrated*. She picked up her first bow at a young age and went on to claim the titles in many tournaments. In 1961, she was inducted into the Willie Heston Living Sports Hall of Fame and was entered into the Michigan Sports Hall of Fame in 1962. (Courtesy of Sports Illustrated.)

In 1960, the Wyandotte resident was crowned Miss Michigan followed by Michigan Woman of the Year in 1970. Her skills and beauty won her national acclaim as well as appearances on popular television programs at the time such as the *Ed Sullivan Show*. (Courtesy of Walter P. Reuther Library, Wayne State University.)

Fighting diabetes most of her life and eventually going blind, Marston had a massive stroke and died March 6, 1971. On September 19, 1971, a memorial service was held at the cemetery with eminent guests including congressman John Dingell, Supreme Court Justice G. Mennen Williams, state senator John McCauley, state representative William Copeland, and 10 area mayors. (Courtesy of Michigan Memorial Park.)

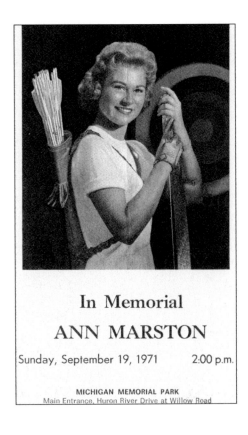

In Memorial

ANN MARSTON

Sunday, September 19, 1971 2:00 p.m.

MICHIGAN MEMORIAL PARK
Main Entrance, Huron River Drive at Willow Road

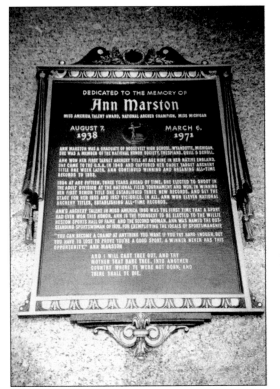

A plaque hangs near the entombment of Marston, located in the Shrine of Remembrance. Television and radio personnel, along with civic leaders, joined in the celebration honoring Marston's life with Paul Williams from WWJ serving as master of ceremonies. CKLW's Jerry Chiapetta and WJR's George Phieffer were in attendance. Marston eventually won 11 national archery titles in her short lifetime of 32 years.

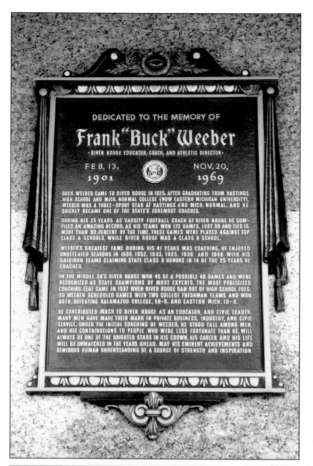

DEDICATED TO THE MEMORY OF

Frank "Buck" Weeber

·RIVER ROUGE EDUCATOR, COACH, AND ATHLETIC DIRECTOR·

FEB. 13,
1901

NOV. 20,
1969

BUCK WEEBER CAME TO RIVER ROUGE IN 1925. AFTER GRADUATING FROM HASTINGS HIGH SCHOOL AND MICH. NORMAL COLLEGE (NOW EASTERN MICHIGAN UNIVERSITY). WEEBER WAS A THREE-SPORT STAR AT HASTINGS AND MICH. NORMAL, AND HE QUICKLY BECAME ONE OF THE STATE'S FOREMOST COACHES.

DURING HIS 25 YEARS AS VARSITY FOOTBALL COACH AT RIVER ROUGE HE COMPILED AN AMAZING RECORD. AS HIS TEAMS WON 173 GAMES, LOST 38 AND TIED 13. MORE THAN 80 PERCENT OF THE TIME. THESE GAMES WERE PLAYED AGAINST TOP CLASS A SCHOOLS, WHILE RIVER ROUGE WAS A CLASS B SCHOOL.

WEEBER'S GREATEST FAME DURING HIS 41 YEARS WAS COACHING. HE ENJOYED UNDEFEATED SEASONS IN 1930, 1932, 1933, 1935, 1936 AND 1949 WITH HIS GRIDIRON TEAMS CLAIMING STATE CLASS B HONORS IN 14 OF THE 25 YEARS HE COACHED.

IN THE MIDDLE 30'S RIVER ROUGE WON 45 OF A POSSIBLE 46 GAMES AND WERE RECOGNIZED AS STATE CHAMPIONS BY MOST EXPERTS. THE MOST PUBLICIZED COACHING FEAT CAME IN 1937 WHEN RIVER ROUGE RAN OUT OF HIGH SCHOOL FOES. SO WEEBER SCHEDULED GAMES WITH TWO COLLEGE FRESHMAN TEAMS AND WON BOTH, DEFEATING KALAMAZOO COLLEGE, 56-0, AND EASTERN MICH. 18-0.

HE CONTRIBUTED MUCH TO RIVER ROUGE AS AN EDUCATOR, AND CIVIC LEADER. MANY MEN HAVE MADE THEIR MARK IN PRIVATE BUSINESS, INDUSTRY, AND CIVIC SERVICE. UNDER THE INITIAL COACHING OF WEEBER. HE STOOD TALL AMONG MEN. AND HIS CONTRIBUTIONS TO PEOPLE WHO WERE LESS FORTUNATE THAN HE, WILL ALWAYS BE ONE OF THE BRIGHTER STARS IN HIS CROWN. HIS CAREER AND HIS LIFE WILL BE UNMATCHED IN THE YEARS AHEAD. MAY HIS EMINENT ACHIEVEMENTS AND GENEROUS HUMAN UNDERSTANDING BE A SOURCE OF STRENGTH AND INSPIRATION.

Frank "Buck" Weeber is memorialized at the Shrine of Remembrance with a plaque in addition to his marker in the Companion Gardens, block 42. Weeber's career as a football coach and athletic director at River Rouge High School spanned over 40 years. He was best noted as having six unbeaten seasons in 1920, 1932, 1933, 1935, 1936, and 1949. Overall, as the coach, he had 173 victories, 38 defeats, and 13 ties, which was unheard of by any other team. In 1937, his high school team played against the college team at Kalamazoo and won 56-0. They also played against Michigan State Normal School, which became Eastern Michigan University, and were the victors, 18-0.

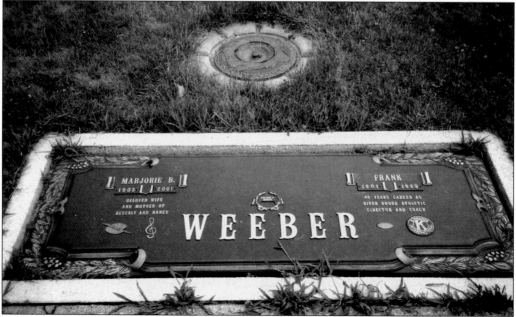

Newlywed Frederick "Bud" Knight Jr. lost his life driving down a rural road; Bud swerved into a ditch to avoid hitting a young boy who carelessly rode his bicycle into the driver's path. The Knight grave site is in the Masonic Gardens, block 41. Before this fatal event, Bud had served in Vietnam. Home on furlough with a buddy, Bud and his mother, Frances, made a bet. The family owned a .22 rifle, so they decided whoever missed a bull's eye drawn on a paper plate target would have to do the dinner dishes. Bud, the U.S. Marine, thought this was an easy contest and was overly confident that he would win. However, Bud did not know what his mother knew. The gun's sight was a bit off and she knew just how much to move the gun to hit the target. Bud and his buddy washed dishes that night.

Mary and Ervin Maveal were joined in marriage with Elzerine Genaw as the best man and a young lady whose only identification is her last name, Loraine. They would add four children to their union, Lillian, Harvey, Ervin Jr., and Wayne. Ervin worked for the Ford Motor Company until he bought a 40-acre farm on Merriman Road, just north of Michigan Memorial Park. Like many living in this area, they trucked their vegetables each Saturday during the summer months to Eastern Market in Detroit to sell their goods to the city folk. (Courtesy of the Maveal family.)

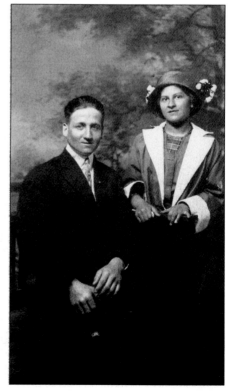

The Maveals, like most people living in the farming community, took time for recreation with their neighbors. Ervin and Mary joined others at Saint Roch's Catholic Church, the VFW, and the VFW Auxiliary. They were proud of their three sons who served in the military. Wayne and Harvey enlisted in the army and Ervin served in the U.S. Army Air Corps. Their daughter was often seen carrying the big American flag in local parades. When Michigan Memorial Park introduced a new Catholic section for burials, Ervin took a job selling plots there, and many were bought by his family. Eventually they sold their farm and built a home located on Huron River Drive, right next to the cemetery. Ervin then went to work for the school district as a janitor. He was so well liked that he was elected to the school board and had one of the athletic fields named after him. The Maveals are buried in the Garden of Eternity, block 23. One of their homesteads was located on Merriman Road, a short ride away from the cemetery.

On July 4, 1942, a vivacious 18 year-old Elaine MacDonald, dressed in pale yellow, was crowned Ecorse's Rowing Queen for the Central States Regatta. She was chosen over other beauties in a popularity contest sponsored by the Ecorse Business Men's Association. Besides the privilege of watching the rowing regatta from the judges' stand, she received gifts including a permanent wave, nylon hose, and $5 worth of war stamps. (Courtesy of Lee Critchfield.)

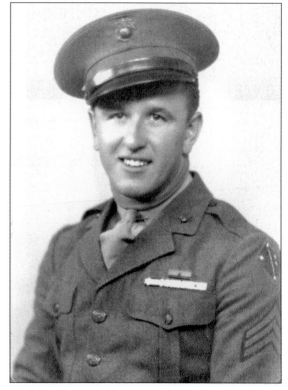

Donald Critchfield served in World War II. As a U.S. Marine, he was stationed in places such as New Zealand and Australia. After leaving the military, he was employed by the Ford Motor Company sewing upholstery on automobile seats and after some time, worked in construction until retirement. (Courtesy of Lee Critchfield.)

MacDonald's widowed mother fell in love and married Critchfield's father, a widower. MacDonald and Critchfield were young adults at that time; they followed in their parents' footsteps and married on January 12, 1946. Elaine and Donald's union resulted in two children, Lee and Linda. (Courtesy of Lee Critchfield.)

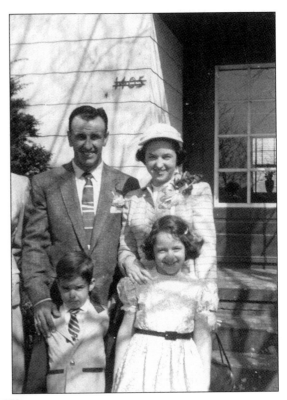

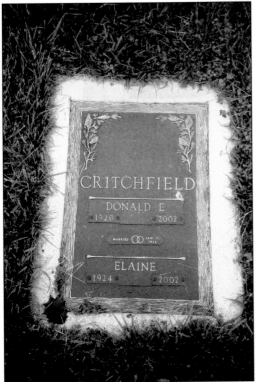

Having been married for over 50 years, Elaine passed away first after many months of illness. Sadly six months later, Donald fighting his own decline, joined her. Their remains are interred in a family plot in the Garden of Charity, block 32, where Donald's father's two wives, as well as himself, are also buried.

On the evening of January 3, 1919, Anthony Giannola, a reportedly Sicilian feudist leader, was gunned down at 189 Rivard Street in Detroit. Newspaper accounts vary, but as he stepped out of an automobile, someone lurking in an alley surprised Giannola and fired five shots, killing Giannola instantly. He was on his way to pay his respects to the widow of another alleged feudist who had been murdered a few days earlier. Giannola came to Detroit in 1901 from Sicily. He and his brother got their start by opening a general store in Wyandotte, formerly called Ford City, as well as other business in Detroit. Becoming a prominent entrepreneur in Detroit's Little Italy, he supposedly became involved in some dangerous activities and an attempt on his life was made in 1911. When he died, he lived in Wyandotte on Biddle Avenue with his wife and five children.

Tragedy struck the Giannola family again when one of Anthony's five fatherless children was killed. Giannola's widow, still living on Biddle Avenue in Wyandotte, was raising the children, with 13-year-old Anthony Jr. being the oldest son. It was February 8, 1924, and Anthony, along with a friend, was hitched to an automobile with his sled. A childish thrill for youngsters back then proved to be fateful for Anthony as it had been for other adolescents. When Anthony let go of the automobile, his sled slid in front of another car and young Anthony was run over. Both father and son were buried in Mt. Carmel Cemetery in Wyandotte, but were later moved to Michigan Memorial Park in Calvary Gardens, block 24. The house the family lived in no longer exists. The home where Anthony Sr. was killed in front of also has been demolished.

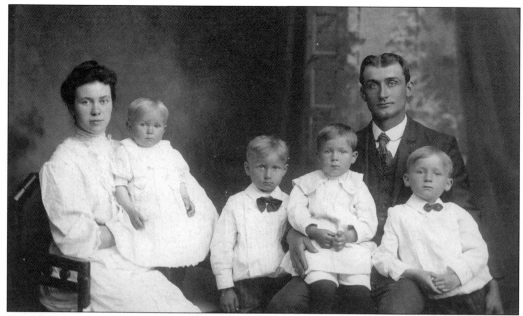

Beryl Zimmerman, sitting on his father's right knee, is joined by his parents, Ethel and Joseph, along with his brothers, from left to right, Keith, Cecil, and Kenneth. After this photograph was taken, the family would be increased by two more children, Orlo and Bernice. As a project engineer for the Wayne County Road Commission, Beryl's first project was to see that Telegraph Road, a dirt road at the time, was paved between Goddard Road and Flat Rock. (Courtesy of Carolyn Gabrielli.)

Beryl was 81 when he passed away in 1986. His career began when he took a job as a trucker driver. When he retired 44 years later, he was a road surveyor. He was a Boy Scout leader and a Mason, and, with his wife, Lillian, he wrote a book about the history of the First United Methodist Church of Wayne. He is buried in the Garden of Peace, block 9.

Orlo married Esther Wharton on October 24, 1936, attended by Stella and Kenneth Wharton. Before marrying, Orlo's family lived in Romulus. Once, their kerosene stove began burning out of control. Bernice was told to run and get Orlo. She woke Orlo telling him to hurry. Grabbing his cigarettes, he stopped to look for matches. Trying to convey the need to hurry, she said, "Forget the matches—you can light a cigarette with the kitchen." (Courtesy of Lillian Nesbitt.)

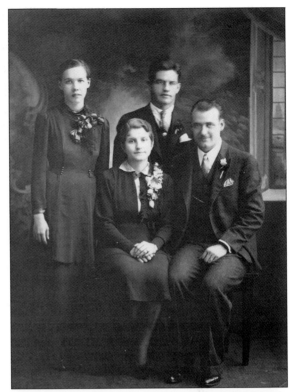

Moving to Ypsilanti, the family would experience another fire. Orlo went into his bedroom and turned the light on. Staying for only a short time, he left the room and turned off the light. A problem with the wiring caused a spark, which set the curtains on fire. Orlo's bedroom was the only room damaged by the fire. He is buried in the Garden of Peace, block 9.

Catherine Lillian Perry became the bride of Harvey Ervin Maveal on June 8, 1942. Their eight children would help with the family businesses, consisting of six rental cabins and a gas station featuring a party store in Flat Rock. The Maveals, along with Harvey's brother Ervin, also owned a small airport where they gave flying lessons. (Courtesy of the Maveal family.)

Catherine had graduated magna cum laude from high school and attended the Detroit Business Institute. Before her marriage, she was a court reporter and a secretary. Harvey also was employed with the General Motors Corporation. Working in their show and display division, he traveled throughout the United States and abroad, including three months in Russia. They are buried in the Garden of Eternity, block 23.

Jerry M. Arthur, who died when he was 72, along with Ida Arthur, his wife, and Iva Arthur, their daughter, were removed from the Mallett Cemetery located not far from Michigan Memorial Park. They were brought to Michigan Memorial Park to join others in the family plot. Iva had died on June 17, 1908, at age 15 from typhoid fever, and Jerry had died on November 8, 1924, from apoplexy, a heart condition. Ida was only 49 years old when she passed away on December 4, 1903. They are buried in Sylvan Gardens, block 7.

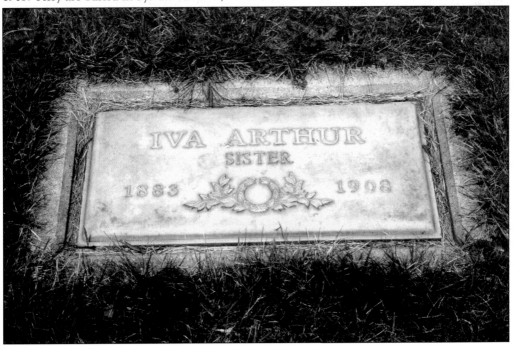

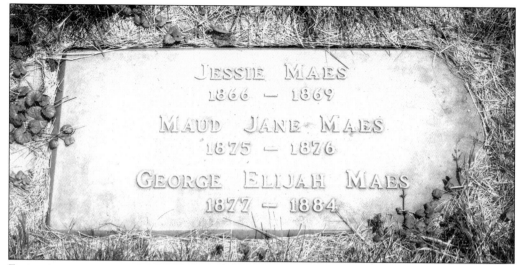

For various reasons, it was not unusual for family members to have their deceased relatives disinterred from one cemetery and then reburied in another. Even so, sometimes the remains of family members would be moved from one section to another within the same cemetery. In Serenity Gardens, block 8, are the remains of three family members who were originally buried in Romulus Cemetery. Jessie Maes was born December 26, 1866, and died August 17, 1869, from whooping cough. Little Maud Jane Maes was born January 15, 1875, and died August 27, 1876, from dysentery. On March 13, 1877, George Elijah Maes was born but lived only until February 20, 1884, due to a blood clot. They were reburied in one grave at Michigan Memorial Park in the Maes family plot on October 22, 1936.

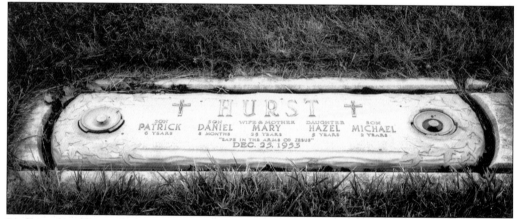

In the early morning darkness on Christmas Day of 1953, Ross Hurst would lose his entire family. He and his wife, Mary, tucked their children, six-year-old Patrick, five-year-old Hazel, two-year-old Michael, and eight-month-old Daniel, into bed and kissed them good night. They had opened a few of their gifts on Christmas Eve and anticipated the next day's fun and excitement of discovering what was inside the still-wrapped presents. The Hursts shared their Flat Rock home with another family, the Eysters. The Eysters, returning home from midnight mass, found the house enveloped in flames. Ross escaped, but the fire trucks arrived too late, and his wife and children perished in the fire. A defective oil heater was later determined to be the cause. Ross's last memory of his wife was seeing her in the bedroom window holding Daniel. Daniel was buried in the same casket with his mother, and they are all buried in the Garden of Eternity, block 23.

110

Victor Perry, age 24, married Lillian Rose Hartwig, age 22, in July 1920. Victor earned the rank of corporal in the U.S. Army before his honorable discharge. Even during the Great Depression, his hard work and determination to be a successful entrepreneur kept the Flat Rock store operational. Pictured here with their son-in-law, the Perrys had only one daughter, having lost a second child at birth. Victor's life was cut short due to illness, and he left behind eight grandchildren. The Perrys are buried in the Garden of Eternity, block 23. (Courtesy of the Maveal family.)

On May 16, 1927, Bessie Szymecko got married on her 19th birthday. Szymecko was born and raised in Ecorse, and her new husband, 23-year-old Lawrence Bosman, hailed from Trenton. After their marriage at St. John's Cantius Church in Wayne, they settled on a rented farm on Sibley Road in Brownstown Township. (Courtesy of Ethel Bosman Maveal.)

After the Bosmans raised two children, Jim and Ethel, they moved to another rented farm a short distance away on Van Horn Road. They stayed there until they purchased a 40-acre farm in Carleton where they stayed until their death. They are buried in the Garden of Eternity, block 23.

Lillian Kraszewski Klimkiewicz Balazy would be widowed twice. Pictured here with her second husband, Alexander Balazy, on their wedding day in 1932, she would be left alone almost seven years later to raise four sons, two from her first marriage and two from her second marriage, by herself. (Courtesy of Edwin Balazy.)

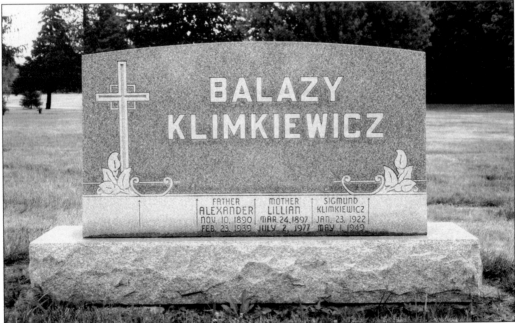

Without any benefits and along with the hardships created by the Great Depression and World War II, Lillian used her talents as a cook to earn a living. During the war, she was a cook for servicemen's club in Detroit and later ran a catering business. Her needlework helped to supplement her income. They are buried in the Garden of Eternity, block 23.

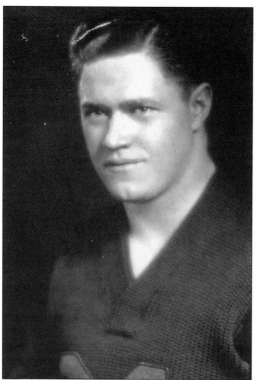

All-American Charles Bernard, known mostly as Chuck, was one of the University of Michigan's most famous football players. He had already made a name for himself as an outstanding athlete at Benton Harbor High School before enrolling at the University of Michigan. (Courtesy of Bentley Historical Library, University of Michigan.)

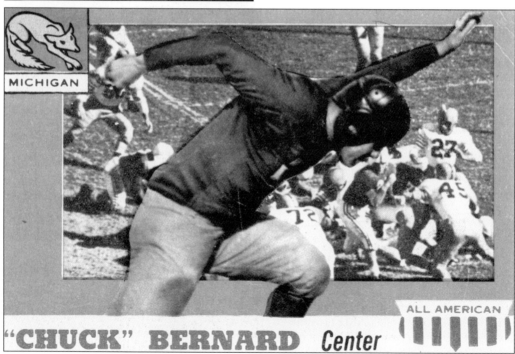

MICHIGAN

"CHUCK" BERNARD *Center*

ALL AMERICAN

Bernard's trading card tells of his ability to "figure out a play in a split second and break it up with ease." He was a great interceptor and was the force that made the University of Michigan's defensive team one of the best.

Bernard stands with other University of Michigan football players. From left to right, Russell Fuog, Chuck Bernard, Herman Everhardus, Stan Fay, and future U.S. president Gerald Ford pose in this photograph taken in October 1934. Bernard and Everhardus sport their achievements as 1932 All-American winners. (Courtesy of Gerald R. Ford Presidential Library.)

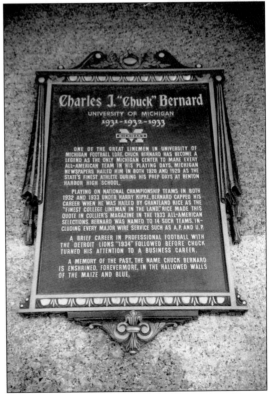

Bernard is immortalized in the Shrine of Remembrance with a bronze plaque marking his achievements. After his success at the University of Michigan, he went on to play professionally with the Detroit Lions. Bernard was only 50 years old when he died March 30, 1962. He is buried in the Masonic Gardens, block 41.

IN LOVING MEMORY
DOROTHY HAENER
DEC. 17 JAN. 6
1917 2001

Dorothy Haener, a union activist and a founder of the National Organization for Women, began her career employed by the Ford Motor Company working at the Willow Run plant. When World War II ended, Kaiser-Frazier Industries moved into the former Ford factory. She was let go due to the new company's policy of hiring military men returning home. She was hired back a couple years later but at a much lower wage. When the United Automobile Workers union was being formed, she found her calling. Being passionate about this newly founded organization, she moved up the ladder and was elected to the bargaining committee fighting for equal pay and fair wages. Meeting Betty Friedan caused her to become one of the founders of the new women's movement and she worked tirelessly trying to get the Equal Rights Amendment passed. She also participated in the Michigan Civil Rights Commission. She is buried in Resurrection Gardens, block 40.

The 1939 winner of the Paganini International Violin Competition, Gennaro D'Alessio spent a lifetime impressing thousands with his extraordinary ability. Born in New York, his family moved to Italy when he was a child. While there, he studied music at Bari, Italy's Niccolo Piccinni Conservatory. He was known for his concerts with Beniamino Gigil, the tenor who rose to prominence with the death of Enrico Caruso. Later he became the concertmaster of the Rome Radio Broadcasting Symphony and played under the direction of Lepold Stowkowski and Pietro Mascagni. Moving back to the United States, he studied opera in Manhattan. Performing at many of the well-known hotels throughout the United States and Europe, including the Waldorf Astoria and the Greenbrier, he played a wide-range of music from Broadway tunes to classical. He is interred in the Shrine of Remembrance, block 19C. (Courtesy of Michigan Memorial Park).

Gino D'Alessio
Violin - Piano
Guitar - Composer

International Artist . . .

Whether it is in the concert hall, the ball room of a renowned hotel, a corner of a small cafe or aboard ship, Gino has delighted audiences, large and small, around the world.

Among European cities, Gino has performed in Rome, Milan, Bologna, Abruzzi, Vienna, Berne, Geneva, Paris, Cannes, London, Trieste, Monte Carlo, Grenoble and Madrid.

From Tunis and Cairo in Africa to Bombay in India to the world-famous Greenbrier Hotel in America, Gino has toured the globe with his music.

Gino brings credentials seldom approached by any musician-composer-arranger. He truly claims the title of International Artist.

What critics say . . .

Sid Ascher — ...one of the truly great violinists — Gino D'Alessio...brings out sweet tones in his violin such as you have never heard before. He is magnificent!

LA NAZIONE, Florence — ... le Trio D'Alessio s'est montré comme un ensemble parfait et très harmonique qui a en occasion, dans un programme tellement eclectique, de montrer ses qualites stilistiques et interpretatives qui le font, a raison, classifier parmi les meilleurs ensembles italiens et etrangers.

BAIERISCHER KURIER, Monaco — ...le Trio D'Alessio s'est tout de suite montré digne d'etre compare aux ensembles de renomee mondiale.

DEUTSCHE ALLGEMEINE ZEITUNG, Berlin — ...le Trio D'Alessio, deja tres bien juge per le public et la critique de Berlin, dans le concert de hier nous a montre toute sa richesse de sensibilite et les exceptionnelles aptitudes interpretatives.

NEW YORK WORLD TELEGRAM & SUN — ...D'Alessio, a concert performer who played under Toscanini in Rome, strolls among the diners and handles selections ranging from Al di La to the Rumanian Rhapsody with facility.

LA TRIBUNA, Rome — ...Trio di D'Alessio durch entusiastischen Applaus fur die ausdrucksvolle Wiedergabe des gut gewahlten Programmes.

The Incomparable Gino . . .

Never before has there been a virtuoso violinist such as 'GINO' whose natural flare for the violin innate talent as a musician and presentation of performance can leave you spellbound.

GINO's playing has thrilled audiences from Excelsior Hotel, Rome, Hotel Piccadilly, London, Monsigneur and Sherazade, Paris, to New York's own Peacock Room, Waldorf Astoria, to the Persian Room, Hotel Plaza, and The Greenbrier.

Gino can play anything from Classical to Gypsy music. He can deviate from pop to show tunes. Always playing with facility, a velvet tone, and has a magic touch on his strings leaving his audiences with wanting to hear more.

His versatility as a musician ranges from Violin, Guitar, Piano, Conductor, Composer and Arranger. He is a truly versatile artist and dynamic entertainer you will always remember playing and enchanting his audiences to the utmost and leaving behind a memory of bliss.

That is why GINO is known as 'GINO and his Magic Violin'.

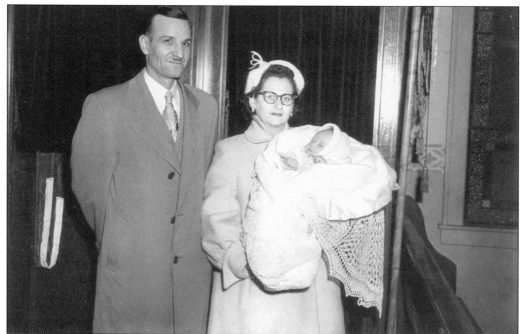

Lillian Maveal, the daughter of Ervin and Mary Maveal, married Eugene Bonk in 1936. They are shown here at the baptism of their niece Becky. Their children, Doris, Eugene Jr., and Karen, would complete their family. Eugene was raised on a farm in Romulus. He met his future wife at Renee's Dance Gardens one summer evening. He worked for the Ford Motor Company before forming his own carpenter-contractor company. (Courtesy of the Bonk family.)

Eugene built homes in the Dearborn area. Not wanting to borrow money, he built his own home and completed each phase as money allowed. They lived in Dearborn and were members of Saint John the Baptist Catholic Church. With his building expertise, he served on the church's building committee, which raised a new church and school. Married more than 30 years, they are buried together in the Garden of Eternity, block 23.

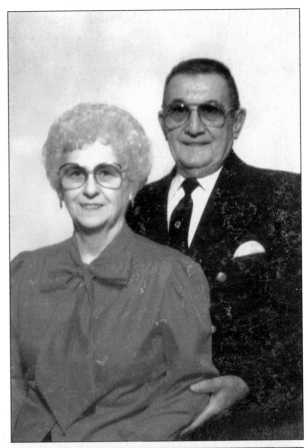

Eugene passed away August 25, 1967. Lillian would then marry Girard Mailloux, another marriage that would last over 30 years. They would spend their married life in Melvindale. Lillian died September 19, 2002. Eugene and Lillian's daughter Karen preceded Lillian in death. Their son, Eugene Jr., makes his home in Berlin, and their daughter Doris, married with a family of her own, has remained in the area northwest of Detroit. Girard is buried in the Bonk family plot in the Garden of Eternity, block 23. (Courtesy of the Bonk family.)

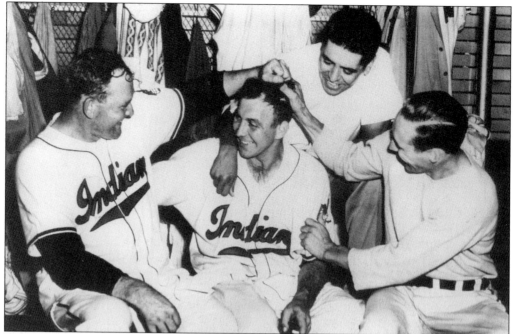

In this August 29, 1949, photograph at Cleveland Stadium, the Cleveland Indians had a double win over the Red Sox, 5-2 and 5-4. Seen here are, from left to right, Al Benton, Mike Tresh, Mike Garcia, and Bob Feller. Tresh had been a catcher in major league baseball. His career lasted 12 seasons from 1938 to 1949, although he had played ball since 1932.

Tresh was a player for the Chicago White Sox until he was traded to the Cleveland Indians in 1949. Tresh made a name for himself by catching all of the Chicago White Sox's 150 games and maintained a .984 fielding percentage. Tresh was originally a Detroit Tiger before being traded to the Chicago White Sox. Dying at the age of 52, he was buried in the Garden of Faith, block 31.

Four

THE LEGACY CONTINUES

Michigan Memorial Park preserves the principles set forth by William Heston. Involvement in the community has spilled over, embracing more non-profit groups than ever before. More burial space has been carefully planned and platted with over 1,600 burials added each year. With over 64,000 burials to date, Michigan Memorial Park has room for many more thousands, enough for several more generations to continue the legacy. Some of the undeveloped portions of the cemetery will continue to be used for charitable functions. Other parts will be platted for grave sites, with other parts being designed for new mausoleums. A 25-foot-tall lighthouse will be erected on the banks of the Huron River. Not to be just a decorative addition to the cemetery, it will encase the pump house that is as old as the cemetery. It will also contain niches for those wishing a burial location by the water. Landscaping is still one of the cemetery's outstanding features that draw many just to come and enjoy its beauty. People arrive with lawn chairs and linger under the cemetery's shady trees admiring the well-placed shrubs, flowers, and sculptures. Its meandering roads, cutting through a profusion of assorted plants and trees, offer a pleasant experience to all who enter its gates. Even though its two famous swans are no longer in residence, Michigan Memorial Park has remained one of the most acclaimed cemeteries of its kind.

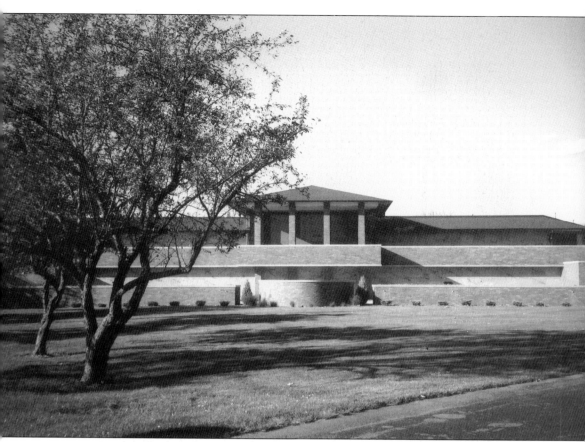

Increased demand for aboveground burial prompted the need of the Garden of Angels, the newest building on the property. Combining practicality with magnificence, this structure not only provides entombment space but also houses the maintenance building. The original maintenance building had seen better days, so Scott Goodsell from G. H. Forbes Associates was consulted. Using the ideas presented by Kelly Dwyer, Barbara Heston, and Heidi Umin, the cemetery owners, and John Fenech, the cemetery's superintendent of grounds operations, resulted in this two-level building that can accommodate approximately 600 crypts and about the same number of niches at this time. The building is in its first stage, with the second and final stage to be completed in the near future, allowing even more entombment spaces. Walking up the stairs or ramp, visitors are greeted by a 60-foot-long black granite reflecting pool. When heated, the pool will remain operational even during the winter months.

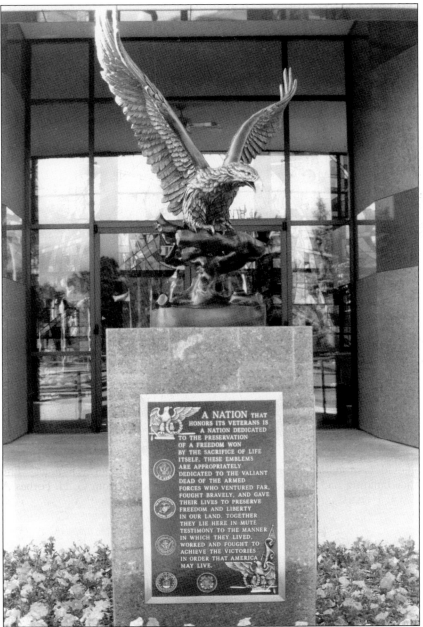

Michigan Memorial Park continues to be an ardent supporter of civic activities. In addition to the traditions started by their great-grandfather, Kelly Dwyer and Heidi Umin, along with their mother, Barbara Heston, have involved the community even more in their activities. A photograph contest was held in 1999 inviting all amateur photographers in the community to submit photographs of Michigan Memorial Park. These photographs could be of the landscape, buildings, wildlife, or anything on the grounds. Huss Huber presented this winning photograph of the bronze eagle monument displayed at the Shrine of Remembrance. With that award came an invitation for Huber to take other photographs of the cemetery. His photographs hang in the family service office located at the main entrance of the cemetery. (Courtesy of Michigan Memorial Park.)

Carr School

May 27, 1998

Dear friends,

Everyone had a great time fishing.

We appreciated being able to use the

pond. Although we caught 274 fish.

We hope we can come back next year.

We really enjoyed lunch.

The food was super delicious.

Thank you for the wonderful time we

had.

Your friends,

The kids who went fishing

Michigan Memorial Park maintains their involvement with the surrounding communities including sponsoring activities held on the cemetery grounds for local school groups. Visually handicapped students from Lincoln Park's Carr School spent the day of May 27, 1998, fishing in one of the cemetery ponds. The cemetery stocked the ponds and, in conjunction with the Huron Valley Steelheaders Association, sponsored the event. This note, which was written in braille by the students and translated by their teacher, is one of many that the cemetery staff receives on a regular basis. Holding to the idea that cemeteries are for the living, and not just a place to visit the graves of loved ones, the staff reaches out to many diverse groups, offering whatever they can do to provide for day trips or other selected activities. (Courtesy of Michigan Memorial Park.)

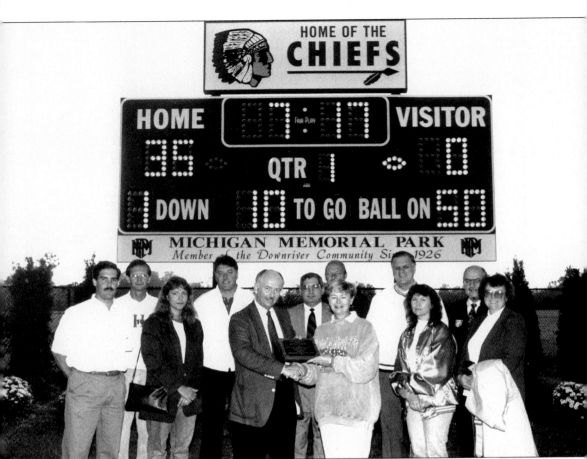

The cemetery has received numerous recognitions from local charitable groups including the Muscular Dystrophy Association, the Red Cross, the Southgate Rotary Club, and an Executive Declaration from the State of Michigan issued by Gov. John Engler in 1996 for its civic involvement. In this undated photograph, the cemetery's founder's granddaughter Barbara Heston (fifth from right) participated in the dedication of the scoreboard that the cemetery funded for Huron High School located across from the cemetery. Michigan Memorial Park's calendar is full of events including blood drives, memorial services, grief seminars, veteran recognition, and outdoor church services. Over its decades of serving the public, Michigan Memorial Park has also been one of the area's largest employers. Having hundreds on their payroll over the years, today the cemetery employs over 50 people. (Courtesy of Michigan Memorial Park.)

Accommodating specific wishes of the deceased or for families wanting more specialized funerals, Michigan Memorial Park offers a variety of services, including the use of a motorcycle hearse. Also available are horse-drawn carriages and hearses, bagpipers, harpists, and a six-piece Mariachi band. Balloons, butterflies, and birds can be released at the funeral service that can be held at sunset, on a Sunday, or on a holiday if it is more convenient for the family and friends to attend. No detail goes unnoticed, including offering funeral guests hot chocolate in the winter months and bottled water on warm days. Escorted down the main thoroughfare to the Shrine of Remembrance for a chapel service or holding a tented graveside service, the cemetery assists the families to make sure the final time with the deceased is memorable. (Courtesy of Michigan Memorial Park.)

In May 1999, Michigan Memorial Funeral Home and Floral Shop purchased 10 acres of land from Michigan Memorial Park to build a new funeral home adjacent to the cemetery. Completed in June 2001, the Frank Lloyd Wright–styled building was designed by G. H. Forbes Associates and covers well over 21,000 square feet. (Courtesy of Daniel Dwyer.)

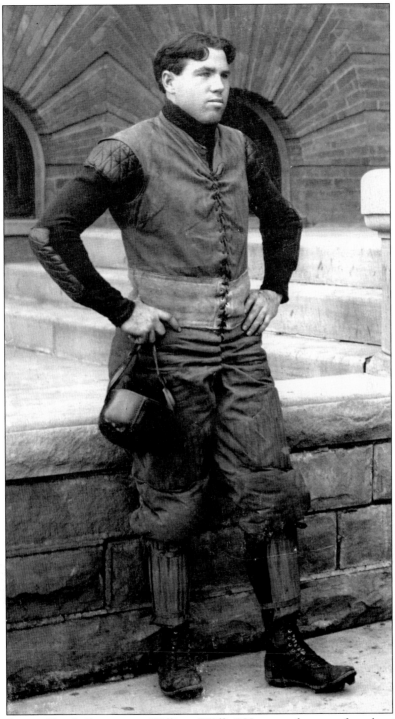

The descendants of football superstar, William "Willie" Heston, who went from having nothing to liberally giving away much that he had, continue to follow the same principles and values that governed Heston's decisions, making Michigan Memorial Park what it is today. (Courtesy of Bentley Historical Library, University of Michigan, Wilfred B. Shaw Collection.)

ACROSS AMERICA, PEOPLE ARE DISCOVERING SOMETHING WONDERFUL. *THEIR HERITAGE.*

Arcadia Publishing is the leading local history publisher in the United States. With more than 3,000 titles in print and hundreds of new titles released every year, Arcadia has extensive specialized experience chronicling the history of communities and celebrating America's hidden stories, bringing to life the people, places, and events from the past. To discover the history of other communities across the nation, please visit:

www.arcadiapublishing.com

Customized search tools allow you to find regional history books about the town where you grew up, the cities where your friends and family live, the town where your parents met, or even that retirement spot you've been dreaming about.